Cartoon Clinic

Ben Cormack

BARRON'S

HA CASS COUNTY PUBLIC LIBRARY
400 E. MECHANIC
HARRISONVILLE, MO 64701

0 0022 0316018 5

A QUARTO BOOK

Copyright © 2006 by Quarto Inc.

First edition for North America published in 2006 by
Barron's Educational Series, Inc.

All rights reserved.
No part of this book may be reproduced in any form,
by photostat, microfilm, xerography, or any other
means, or incorporated into any information retrieval
system, electronic or mechanical, without the written
permission of the copyright owner.

All inquiries should be addressed to:
Barron's Educational Series, Inc.
250 Wireless Boulevard
Hauppauge, New York 11788
www.barronseduc.com

ISBN-13: 978-0-7641-3257-5
ISBN-10: 0-7641-3257-1

Library of Congress Control No.: 2005920490

Conceived, designed, and produced by
Quarto Publishing plc
The Old Brewery
6 Blundell Street
London
N7 9BH

QUAR.CACL

Senior editor: Jo Fisher
Art editor: Sheila Volpe
Assistant art director: Penny Cobb
Copy editor: Tracie Davis
Designer: Tanya Devonshire-Jones
Illustrators: Ben Cormack, Kevin Crossley,
Ricky Thaxter, Gary Swift, and John Woodcock
Picture researcher: Claudia Tate
Proofreader: Claire Wedderburn-Maxwell
Indexer: Diana LeCore

Front cover images by Ricky Thaxter
Back cover image by Peter Maddocks

Art director: Moira Clinch
Publisher: Paul Carslake

Manufactured by PICA Digital, Singapore
Printed by Star Standard Industries (PTE) Ltd, Singapore

9 8 7 6 5 4 3 2 1

Contents

Introduction

I love everything about cartoons. They are so **fresh** and **vibrant**, so **versatile** and **bold**. From the smallest one-frame skit in the morning paper to the latest animated blockbuster movie, cartoons inject **color** and **excitement** into our lives in a deliciously light-hearted and whimsical way. I am assuming since you took the time to pick up this book, you feel the same. ✚ So how am I going to help you achieve your goal of becoming a **cartoonist**? Simple! I am going to join you on your quest, **guiding** you through lessons that will help you to develop the skills you need, and **prescribing** tips and **dispensing** advice along the way. All that is required from you is a keen interest in the subject, and most important by far, **lots and lots of practice**. ✚ So don't waste another minute in the waiting room, **grab your pencils** and let's get this surgery in session!

The doctor will see you now.

Dr. Ben Cormack

THIS WAY

How to Use This Book

This book is not your typical teaching aid because cartooning is not your typical subject. Instead of following instructions and committing facts to memory, which can be dull, cartooning is all about tapping into your creativity and expressing your own ideas. However, that is not to say it is easy. Becoming a proficient cartoon artist is a long and laborious process, and finding your own style is a complex procedure of experimenting and refining. The key to learning how to draw in any style is practice. This book will help you develop a cartooning style and give you practice ideas. You can then come back to it later, using it as a reference when problems arise. If you remember the tips and guidelines while you are working, you should be able to avoid the common difficulties and quickly improve your skills.

The book is organized into five chapters. The first four chapters explore tools and equipment, drawing basic elements, inking and coloring techniques, and composition and layout. Each chapter contains tutorials that deal with different areas to practice. The tutorials are interspersed with "clinics" where common cartooning problems are highlighted and solutions suggested. The final chapter consists of a gallery of work in a range of cartoon styles that should give you some fresh ideas and inspiration.

This way please

TUTORIALS

These units introduce the basics of cartoon drawing. Each tutorial looks in detail at a different aspect of cartoon art and gives instructions on how to work at improving your skills.

Annotations point out specific features of the specially commissioned artwork

Captions discuss important topics within each tutorial

Tutorial name and number

Cross-reference to other related tutorials and clinics

Description of the embarrassing complaint

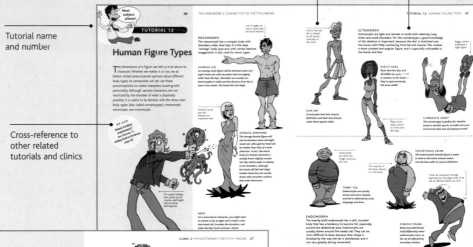

The doctor's reply, with suggestions for recovery

CLINICS

Each group of tutorials is accompanied by one or more "clinic" spreads, tailored to the preceding set of lessons. These examine some of the common problems that afflict inexperienced cartoonists and explain how to overcome them.

GALLERY

The gallery at the end of the book includes examples from cartoon styles as diverse as manga and pop art, and demonstrates an inspiring range of possibilities.

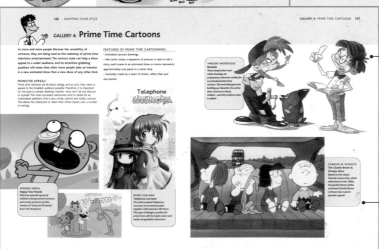

Examples of cartoons drawn by professional artists

Description of the cartoon with information on the style and how it was rendered

Inpatients This Way

Cartooning is all about having fun, but with the right environment and tools, it can become a very fulfilling and creative experience. ✚ As a cartoonist, you will devote a lot of time to practicing your art, so it is important that you have a **comfortable working environment**. Distractions of any kind are detrimental to creativity, so your cartooning environment needs to be just as you like it before you start. A comfortable space free from distractions can be an **artistic hub**, from which you can pilot your journey from aspiring amateur to cartoon guru. ✚ The basic tools of your trade are **pencil and paper**, but how do you select what you need from the vast array of artist's materials available? In this section, we look at the tools you will find most useful. ✚ Plus, we examine the thorny issue of **inspiration**. Where does it come from? How can we stimulate it? And what if we lose it? ✚ Put simply, this section explores all the things we need to think about before putting pen to paper. From **workspace** to **tools** to **inspiration**, the doctor has the prescription for pain-free progress.

Next subject please!

TUTORIAL 1

SEE ALSO
Need further treatment?
See Tutorial 6:
Practice Makes
Perfect—Sketching,
page 24

Stethoscope, Scalpel...Pencils

For a cartoonist the essential tools of the trade are pencils, pens, and paper. But which type of pencil or pen should you use? And which paper? There is a huge selection of artist's materials to choose from, so which ones are right for you? The best advice is to start with the humble pencil, because that is all you really need to develop your skills. Being a whiz kid with a dip pen is an impressive feat that produces some amazing results, but there is no point in spending money on expensive equipment until you feel ready to use it.

PENCILS

You will most often use pencils when you are drawing. Pencils range from hard (H) to soft (B for black), and are graded numerically according to hardness. HB (hard/black) sits in the middle and can give you a good indication of where on the scale you may like to start.

On B pencils high numbers relate to greater softness (with the softest being 8B and the hardest 2B). It is usually best to start with a softer lead (3B or 4B), because it glides more easily on the paper, and while you are learning you will want to loosen your wrist and practice producing smooth, organic lines and shapes. B pencils are also better for producing finished cartoons because the lead is darker and produces very black lines, but the lines can be difficult to erase because they smudge easily.

The higher the number on H pencils, the harder (and lighter gray) the lead. H pencils create a more defined line that is easier to erase than that of B pencils, but they can leave a visible indentation on the paper and therefore require a more confident and immediate style. If you score the paper with a pencil, it can cause ink to bleed when it is applied over the top.

Mechanical pencils are refillable and accommodate leads of different hardness and thickness. They create a more consistent line and have a distinctly different feel to wooden pencils. Most artists use thicknesses of 0.5 millimeter or 0.7 millimeter, but thicker leads can be useful for shading.

PAPER

Paper comes in two main varieties: "hot-pressed" paper, which is thin and smooth giving less resistance to your pencil, is more common and usually less expensive; "cold-pressed" paper, which is thicker and has a coarser, more grainy texture, is more expensive and harder to find outside art material shops. Hot-pressed paper is great for practicing (a cheap pad of letter-sized paper is ideal for working on your smooth, fluid hand movements). However, many cartoonists prefer cold-pressed paper for professional work as it doesn't bleed (spread ink and paint) as much and has a slightly more professional aesthetic.

ERASERS

There are several types of eraser. A rubber eraser is an ideal starting point, but as your skills improve and you branch out with equipment and techniques, it is useful to keep a range of types and shapes of eraser so you are prepared for every situation.

Rubber erasers are the most common type and are fine for general use where not too much cleaning is required, but they do not work so well on smooth or shiny surfaced papers. Do not use a hard "ink eraser" as it will rip the surface of your paper.

Art gum erasers are ideal for charcoal and very soft pencils, specifically when used on thick, rough-textured art papers.

Plastic erasers are useful for smooth papers, although they sometimes lift ink and paint in addition to pencil lines, so be careful if you are removing pencil lines after you have gone over them in ink.

Kneadable erasers look and feel like putty and you can mold them in your hand. They are perfect for removing fine pencil strokes among ink lines and do not harm your paper.

PENS AND MARKERS

Pens and fiber or felt tip markers are inadvisable for beginners because you cannot erase ink easily and it tends to smudge. However, once you feel confident about using ink, you might consider experimenting with some of the following cartoonist's favorites.

Technical pens are not ideal for expressive drawing as the nibs give a uniform, monotone line. However, they are good for even stippling and graphical work that demands straight edges.

Dip pens are traditionally the pen of choice for the cartoonist, but they are difficult to learn to use. When choosing a dip pen, your first consideration should be comfort, but make sure the pen has a nib that produces a consistent line and is flexible and durable. It is best to start with a "writing pen," and move on to a drawing or mapping pen as your confidence increases. Dip pens have the advantage of being able to use waterproof ink.

Fountain pens do not have the versatility or range of the dip pen, and the ink used is not waterproof. However, they are comfortable to use and have the advantage of not needing to be dipped in ink every few seconds. Because the range of nibs available for fountain pens is limited, you cannot achieve such fine detail as you can with a dip pen or mapping pen.

Doctor's Notes

✚ *It is often worth paying extra for quality pencils, as they will save you the frustration of dealing with brittle leads, wood that splinters when you sharpen it, and levels of hardness that do not correspond to the description.*

✚ *Your drawings may smudge and look messy while you are practicing fluid movements using a B pencil. Once you are confident that your lines are flowing with ease, you can graduate to a harder lead, until you are mostly using H pencils for outlines and B pencils for shading.*

Fiber tip and felt tip markers are quick-drying and produce a denseness of color that is particularly suitable for reproduction. Fiber tips are perfect for line work; make sure the pen carries the word "permanent" otherwise the ink will not be waterproof. Larger felt tips are usually cut in a chisel shape that is practical for flat areas of color.

Next subject please!

TUTORIAL 2

SEE ALSO
Need further treatment?
See Tutorial 26:
Applying Color,
page 94

Paints, Inks, and Other Equipment

If you want to add color to your line work, there are many ways to do it. This can be one of the most fun parts of the cartooning process—try experimenting with the different types of paints and inks available until you discover a coloring style you like.

When you're adding color, you'll also need to think about acquiring equipment such as brushes and mixing palettes. Some other useful cartooning tools are also outlined here.

Gouache (sometimes known as "body color") is watercolor paint with the addition of white pigment. This forms a heavier paint with a flat, opaque covering power that is particularly suitable for reproduction. This opacity means you can paint light over dark, which is useful for detailed cartoon work such as highlights. Its masking power means that correcting mistakes is very simple. Gouache paints come in tubes or bottles.

PAINTS
Useful for background washes. A variety of types of paint is available: think about the look you're after and decide whether you want the subtlety of watercolors or the strength of color offered by acrylics. The main kinds are outlined below.

Acrylic paint has certain qualities that make it very useful for the cartoonist. It is quick-drying and waterproof when dry. It is a very flexible medium: when mixed with water, it has many of the characteristics of watercolor, yet because it is waterproof, washes can be overlaid without mixing with each other. Undiluted, or mixed with white, it has some of the covering power of gouache. Acrylic paints come in tubes or bottles.

Watercolor paints are known for their transparency. This allows an infinite number of gradations of tone from the lightest (the white of the paper) to the darkest (undiluted black), through building up washes—one of the most important watercolor techniques. Watercolor paints produce results that are lighter and less defined than acrylic or gouache. While they are worth experimenting with if you have the time, they are not commonly used in cartoons because of the mottled textures they produce. They are available as dried cakes or tubes of liquid paint.

INKS

If you intend to produce your work for print, you need to choose inks that will reproduce well. Drawing inks are made especially for artists; they are waterproof (so will not smudge or run) and come in a wide range of colors. They dry quickly to a glossy finish, making it possible to overlay with another color. India ink is black drawing ink and is still considered the only durable, lightproof ink. Nonwaterproof inks include the writing inks generally used with fountain pens. Also available are special drawing inks in various colors that behave more like watercolors—they tend to be absorbed by the paper and dry to a matte finish. Overlaid washes will combine as the ink is not waterproof.

A good shape to start with is a round brush, which finishes to a point. These range in size from 000 to 14; try a 0 point for line work and a size 8 for broader areas and washes.

BRUSHES

Brushes are used by professional cartoonists probably as often as pens. They can be used to apply both paints and inks, and, although less easy to use than pens, have a flexibility and lightness of touch that many artists value. A huge range of sizes and shapes is available. Price usually indicates quality; the more expensive brushes, such as sable, will last longer. A good brush should retain its point when wet—test this by dipping it in water or licking the tip before you buy!

OTHER EQUIPMENT

Arm yourself with these few extra bits of equipment—they'll help to make drawing and coloring your cartoons a whole lot simpler!

A good cutting mat and knife will make life much easier if you have to cut paper to size or prepare patches to correct artwork. A metal rule will also be an invaluable tool when cutting.

If using paints, you will need a palette on which to mix them. Artists' palettes, available from most craft shops, are ideal as they're divided into lots of sections so you can have several mixes underway at any one time. However, if you don't want to splash out right away, an old dinner plate will work perfectly well. The paint will mix easily on the smooth, nonporous surface, and won't seep through and stain your worktop. White mixing surfaces are best because you know the paint will appear the same color on both palette and paper.

Masking tape is a useful aid for securing your art to the work surface to prevent it from slipping. It's also helpful in producing clean, neat edges to parts of your paint or ink work.

Next subject please!

TUTORIAL 3

Cartoons and Computers

Although by no means essential, computers can be invaluable to a cartoonist, especially if you are working professionally. Cartoons can be drawn on a computer with illustrating programs that use different processing methods: bitmap or vector graphics. The two different approaches are discussed below. However, the most popular use for a computer is for altering images acquired from other sources such as a scanner. You can make changes, correct mistakes, and add color far more quickly and easily than you can when working on paper.

At the right resolution, bitmaps look clean and crisp.

BITMAPS

Using an illustrator program that produces bitmap images is similar to drawing on paper. You draw onto a page on the computer screen using a mouse or a stylus and graphics pad (like an electronic pencil and paper). However, it is difficult to learn the hand-to-eye coordination required for good cartooning because your hand does not go near the point where the "ink" is applied to the "canvas."

Drawing programs enable you to create perfect circles and straight lines as well as quickly "fill" areas with uniform color. Illustrations usually look good because they are neat with smooth lines, uniform colors, and no smudges.

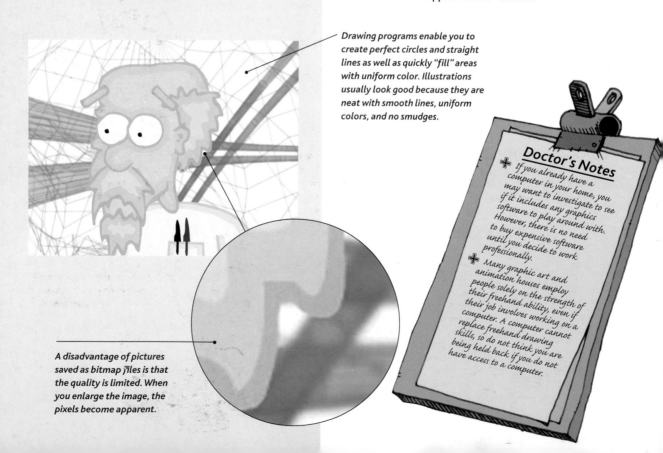

A disadvantage of pictures saved as bitmap files is that the quality is limited. When you enlarge the image, the pixels become apparent.

Doctor's Notes

+ If you already have a computer in your home, you may want to investigate to see if it includes any graphics software to play around with. However, there is no need to buy expensive software until you decide to work professionally.

+ Many graphic art and animation houses employ people solely on the strength of their freehand ability, even if their job involves working on a computer. A computer cannot replace freehand drawing skills, so do not think you are being held back if you do not have access to a computer.

VECTOR GRAPHICS

Programs that produce vector-based drawings are popular, especially with artists such as cartoonists and cartographers who predominantly use line drawings. Illustrations are constructed from mathematical shapes instead of pixels and are therefore easier to manipulate.

With vector graphics the lines of the picture are made up of small points or "vertices" on the virtual canvas (similar to a high-tech dot to dot). You can move the vertices around to fine-tune your drawing, and you can change the color and thickness of your lines at any stage.

One invaluable feature of vector graphics is that you can zoom in on your picture as much as you like without losing quality—the computer simply redraws a bigger version. The gray dots seen above are the vertices that may be moved as required.

IMPROVING FREEHAND PICTURES

Rather than taking over from freehand skills, computer technology is frequently used to improve hand-drawn illustrations. Pictures can be corrected, colored, and edited quickly and easily.

1 Start by scanning in a hand-drawn picture, preferably in a high resolution— 300 dots per inch is the standard for printed images, whereas your computer screen will be around 72.

2 With this particular picture, the cartoonist was not happy with the character's left hand, so used a computer program to erase it and superimpose another picture of a hand (which was drawn separately) over the top.

3 Use the computer to adjust the levels and contrast of the image, so the ink stands out more against the background. You can use the same functions to clean up the background.

4 Now begin to add color. Some programs will allow you to select an area with the click of a mouse button, and then paint exclusively in that area without going over the lines. You will not improve your painting skills, but it saves a lot of time.

5 The cartoon is complete with the correction in place, clean lines, and strong, even colors.

Next subject please!

TUTORIAL 4

Creating a Workspace

Many professional cartoonists use a drawing board as their workspace. These are very practical because they are large, adjustable, and mounted at a slant so they are ideal to draw on. Another advantage is that you cannot cover them with clutter. However, they are cumbersome, expensive, and often industrial-looking and ugly, so you may not want to invest in one immediately. Instead, create a space in your home that will encourage you to work. Factors to consider include a desk, lighting, and the surroundings.

ORGANIZERS

Keep all your materials close to your desk. Put your favorite pencils in one container on your work surface so you'll always know where they are. Materials that you do not use all the time should be stored close by but out of the way so that they do not clutter your drawing area.

A clean, clear workspace creates an effective environment for work. Avoid covering your desk with old bits of paper, cups and plates, crumbs, dust, books, and disks. Your workspace should look clean, professional, and inviting.

Keep all your materials organized in separate containers so that you can always put your hands on a particular pen or eraser. This will help you avoid those frustrating moments when you risk losing a fantastic idea because you must stop to hunt for a specific tool or favorite pen.

LIGHTING

Your workspace needs to be well lit, ideally with light coming from more than one source, so you do not create shadows as you lean over your work. Swing arm lights are useful because you can adjust them to suit your needs. Choosing a room with a good source of natural light is also recommended. If you are left-handed, position the light source on your right; if right-handed, place the light on your left.

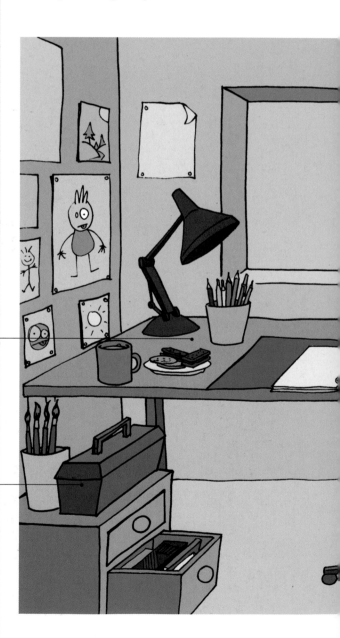

DESK

The most important element of a workspace is the desk. Choose the largest you can because you do not want to be constricted physically. You need freedom to move and lots of space for your materials.

SEE ALSO
Tutorial 1: Stethoscope, Scalpel... Pencils, page 12; Tutorial 2: Paints, Inks, and Other Equipment, page 14

Choose a surface free from lumps, bumps, nicks, and scratches. These may influence the movement of your pencil when drawing on the paper, and you want to keep your lines smooth and even. When you have chosen a suitable surface, you can cover it with a large sheet of blotting paper for extra smoothness.

If you use a computer to create your cartoons, ensure that the screen is free from dust, dirt, and fingerprints. These can blur the screen and lead to eyestrain. Make sure that the screen is positioned so that the top is no higher than eye level.

INSPIRATION

You may want to decorate your workspace with a few inspirational pieces. Posters and postcards work well because they will not clutter your desk. Assemble files for all your notes on cartooning ideas, preferably divided into sensible sections, and keep them where they are easily accessible.

Choose a comfortable chair that is the right height for your worktable. One with adjustable height and back support is ideal, but an extra cushion or two may help.

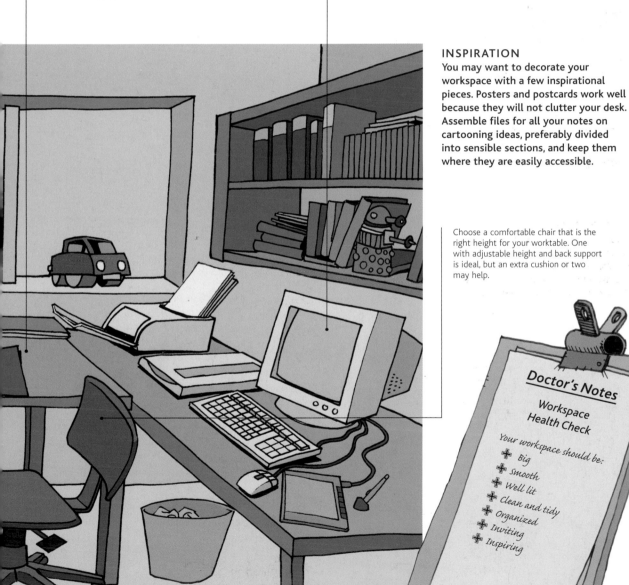

Doctor's Notes

Workspace Health Check

Your workspace should be:
+ Big
+ Smooth
+ Well lit
+ Clean and tidy
+ Organized
+ Inviting
+ Inspiring

Clinic 1: *Hygiene Tips*

Doctor, Doctor! I'm having panic attacks! What if I make a mistake?"

THE DOCTOR WRITES:

"Relax! Cartooning is all about having fun. It is inevitable that you will make mistakes, so try not to be upset when a drawing does not come together in a few minutes. Use a pencil whenever possible so that you can rectify mistakes more easily. Until you are confident you can do it, do not draw with ink. It smudges easily, is difficult to erase, and can leave pictures looking messy unless you are extremely careful. Avoid smudges and spills by keeping your work area and equipment clean.

Generally, unless a spoiled drawing is a vital piece of commissioned work, it is best to write it off as a lesson learned and move on, but if you are determined to revive your image, here is what to do."

SYMPTOMS
- Lopsided lines
- Irregular inking
- Problematic pencils

PREVENTION IS EASIER THAN CURE

Wash your hands before you start drawing. This tip can save you much frustration. You do not want to add the finishing touches to a painstakingly crafted masterpiece only to realize you have inadvertently rubbed grime into it.

Inks and paints will dry out if stored for too long.

For ease of use, store your materials neatly and tidily.

Store your pens and pencils upright and check them regularly for leaking ink and broken leads.

SEE ALSO
Need further treatment?
See Tutorial 31:
ER: Making Good
Your Screw-ups,
page 110

SALVAGING PENCIL DRAWINGS

If you are drawing with pencil, you can simply use an eraser to remove the mistakes. Although you should practice with a soft lead pencil to train your hand to make fluid movements, move on to harder leads as your expertise grows, as these are easier to erase.

Keep a variety of different types of eraser from hard to soft in various states of erosion. Erasers with corners are more precise, but smooth-edged erasers are best for when you need to correct a large area.

If you need to erase a large area of pencil, start from a clean area of the paper and work through the graphite systematically. If you smudge the graphite, it is often difficult to fix.

Correcting ink mistakes is more difficult, but not impossible!

SALVAGING INK DRAWINGS

If you make a mistake while drawing with ink or paint, leave the work to dry for half an hour.

With large spills, blot (not wipe) the paper with tissue to help it dry faster, but do this very gently or you will damage the paper.

Use process white to hide ink mistakes.

Once a spill is dry, simply draw or paint over the top with the required amendments. Carefully cover areas of unwanted ink or paint with "process white"—a white, paintlike fluid that is preferable to ordinary white paint because it has been specially treated to be camera-friendly.

Next subject please!

TUTORIAL 5

Getting Inspired

As a cartoonist, your imagination is your greatest asset and you need to keep it finely tuned and in tip-top condition. You are in the extraordinary position of being constricted only by what you can draw, so it is vital you let your imagination explore the four corners of the universe—and everything in between! Ideas and opportunities for inspiration surround you at home, at work, in the street, in the people you meet, and the media you consume. It is essential to sample a wide variety of what is available on television and in movies, in books, and on the radio, and it is important to open your mind to the things that may inspire you.

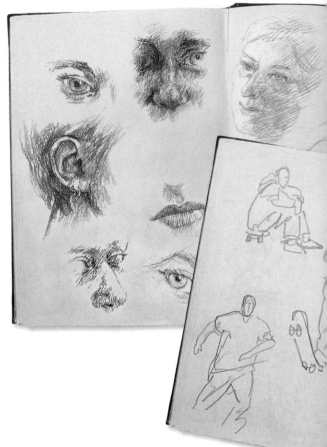

Seek out other cartoonists or artists. Spending some time in the company of other creative people will reenergize you.

SEE ALSO
Need further treatment?
See Chapter 5:
Adapting Your Style,
pages 112–137

FEED YOUR IMAGINATION

By working outside with a little portable sketchbook or pad, you will observe at firsthand the limitless variety of figure subjects to draw. And by doing so, you will increase your responsiveness to creating the lightning sketch. Sports fields and play areas are great places to capture the dynamics of movement.

An inspiring piece of art can help us think in a different context. If something helps you to think in a new way, develop the idea and see what happens. When you think about things differently, you may stumble upon original ideas of your own that you can convert into cartoons.

Try something different and experiment with a variety of drawing materials. Play around with paints, pens, pencils, pastels, and charcoal and give your characters a completely new look.

CARRY A NOTEPAD

Coming up with ideas for your cartoons may seem daunting at first, but the more you come up with the easier you will find it, so carry a pencil and pad with you wherever you go and scribble down anything that makes you laugh, cry, or react in any way. Forming as many ideas as possible will rid you of inhibiting preciousness, which can hold back ideas because you are worried they may not work.

PRACTICE, PRACTICE, PRACTICE

Practice your drawing regularly and incorporate as many of your own ideas as possible into your sketching so that you gain confidence and motivation. This will help you to become better at turning your ideas into real cartoons.

QUICK TIPS TO JUMP-START YOUR CREATIVITY

• Another way to get out of a creative rut is to change the format of your cartoon. If you're working to a portrait format, try the subject in a landscape format and vice versa. Even try shoehorning the drawing into a triangle or a circular format.

• Aim to finish one cartoon. This can give you the confidence to go on to finish more.

• Choose another angle. If you're up against a creative block, consider approaching the piece from a different angle. For example, how would an older person or a child see the cartoon? Perhaps the humor should be altered?

TUTORIAL 6

Practice Makes Perfect—Sketching

Sketching will improve your freehand drawing ability. It is one of the most effective and important elements of the learning process, so always have a sketchbook handy. Sketch before bed, during lunch, whenever the mood strikes you. You will find that it soon becomes second nature and you will quickly fill your sketchbook with myriad ideas that you can come back to when your inspiration fails you. To practice getting down new ideas, you need to draw all the time.

If you do not sketch regularly, you cannot improve your skills. Practice helps us to increase our familiarity with our tools and subject matter. Every time you sketch, the things you have to remind yourself about when you draw will steadily become second nature. When this information is stored in your memory, it adds to your skills as an artist and boosts your confidence. If you are frustrated sitting at your workspace, grab a pencil and pad and go somewhere inspiring. The park is a good place to start because there are so many different subjects to draw.

DECIDE ON WHAT YOU'RE NOT GOOD AT AND THEN PRACTICE DRAWING IT!

Do not waste time going over the things you are already good at—badly drawn elements always stand out in illustrations, so assess what needs improving and devote some time to bettering it. It is extremely fulfilling when you conquer a problem area that has been plaguing you, and the skills you learn while working on your weaknesses will invariably help you in other areas.

CONCENTRATE ON YOUR WEAKNESSES

Hands are notoriously difficult to draw, so they could be a focal point for your practice. Draw your left hand (or right hand if you are left-handed) in various positions as a useful reference for when you are life drawing. When you are happy drawing hands from life, try cartoon hands. They come in all shapes, sizes, and styles, so try to draw as many as possible in a range of styles and positions.

CHOOSING YOUR PAD

Beyond the obvious practical considerations when purchasing sketch pads (you'll want a small one to stick in your pocket when you're out, and a larger one for at home), it's advisable to go for the thinnest, cheapest paper you can find. Look for the smooth stuff used to make newspapers. Your pencil should slide over the slick surface, helping you to loosen your wrist and allowing you to craft quick pictures with smooth, organic curves. This type of surface is ideal for improving hand-eye coordination.

SEE ALSO
Need further treatment? See Tutorial 13: Hands and Hand Gestures, page 48

COOL CREATURES

Sketching animals is a great way to improve your skills at representing shape and form because there's so much variation from one creature to the next. Jumping in at the deep end and working out your own techniques for drawing difficult things like paws and fur will help you make dramatic technique improvements in no time. Animals are great subjects if you catch them during one of their frequent siestas— they lie in the same position for hours!

Push yourself by drawing unfamiliar anatomy from unusual angles.

New subjects to draw + lots of practice = big improvements.

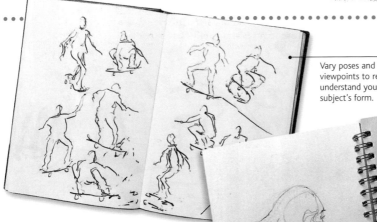

Vary poses and viewpoints to really understand your subject's form.

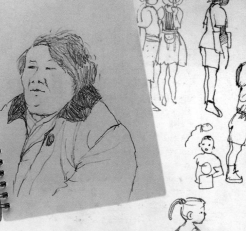

ON THE ROAD

One way to learn to work quickly and develop a visual memory is to take your sketch pad on a bus journey. You won't have time to finesse an image before the bus has moved on, so you'll have to work fast, holding the impression long enough in your mind to make a representative. Drawing on the move also teaches you not to mind a few wobbly lines.

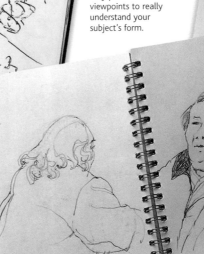

Don't be fussy—sketch anything and everything.

Clinic 2: Physiotherapy for Stiff Fingers

Doctor, Doctor! Some days nothing seems to go right—

my fingers won't do what I tell them and I'm too stressed to draw!"

SYMPTOMS
- Tight fingers
- Inability to focus
- Acute frustration

THE DOCTOR WRITES:

"This affliction plagues all of us at times, but it can be easily fixed with a few simple exercises. While training to be a top cartoonist, you need to keep your fingers supple. There is nothing worse than cold, inflexible fingers when it comes to cartooning because swift, fluid movements are essential. You wouldn't use a pickaxe to shape a sculpture, or a whistle to play a symphony, so don't use cold hands to draw a cartoon."

WARM UP

Drawing when your hands are stiff and cold can be uncomfortable and frustrating; this will make for poor results. Before you put pencil to paper, it may benefit you to spend a few minutes gently warming your fingers by rubbing them together until they feel more responsive and move freely.

Just like other parts of the body, your fingers will benefit from a warm-up before exercise.

Warm up your hands naturally by rubbing them together—stay away from radiators or heaters.

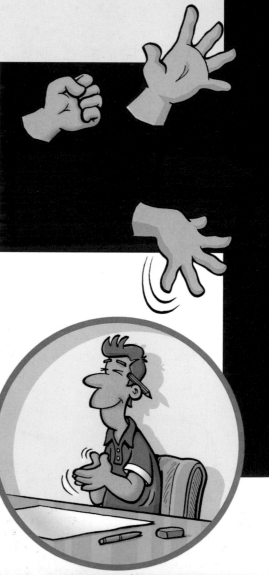

LOOSEN UP

A few 30-second rough sketches at the start of a session can quickly get you into the right frame of mind. Don't worry about the intricate details, Just use loose, quick lines to try and get a basic likeness of your subject, and make sure you stop after 30 seconds. This technique swiftly loosens the wrist and recalibrates hand-eye coordination, which helps prepare you both physically and mentally for your session.

At your workspace, make sure you are comfortable before you start.

CHILL!

The creation of cool cartoons requires a certain frame of mind. Ideally, you should be comfortable and relaxed, and keen to get scribbling. Your creative juices should be in full flow, your head overflowing with inspirational ideas ready to flood onto the page. While we can't easily control how inspired we feel, there are certainly plenty of ways to get into a relaxed mindset ready for a productive cartooning session. Approach cartooning in the right way and it will soon be clearly visible in your work.

Try to remove distractions from the area, so you will not be disturbed mid-session.

Take time to wind down before you practice (stress and cartoons don't mix), and only go to your workspace when you feel ready to work.

Next subject please!

TUTORIAL 7

SEE ALSO
Need further treatment?
See Clinic 9:
Using Clichés in an Emergency,
page 86

Exciting Writing

The key to creating an engrossing character is to build up a detailed personality that your audience will either have an affinity with, or find curious in some way, and place that character in interesting circumstances. If you create cartoon characters that are multifaceted and intricately structured you can make them consistently appealing and interesting without becoming repetitive. Here we cover a few of the important elements that go toward an exciting cartoon.

PLANNING
Think out your characters fully before you start. A flimsily structured, two-dimensional character won't hold your audience's attention for very long, so take some time to thoroughly build up a personality. Start by coming up with a basic premise for a character, then spend time refining it with personality traits and mannerisms, all before writing the first speech bubble. This process cannot be rushed!

STRUCTURE
Your stories should have a beginning (to set the scene and introduce the cast), a middle (to layer the characters and story), and an end (where an exciting or interesting conclusion gives your audience closure).

REVELATION
A revelation, such as finding out a previously unknown fact about your character that changes the course of the adventure, will spice up your story and stimulate your audience. Have a long-lost brother turn up with some news or give a character x-ray vision for a day.

INSPIRATION
Read! The best way to learn how to construct interesting stories is to become well versed with the process. Read a wide range of literature—don't just limit yourself to what you know. A good book or graphic novel can be inspiring as well as educational.

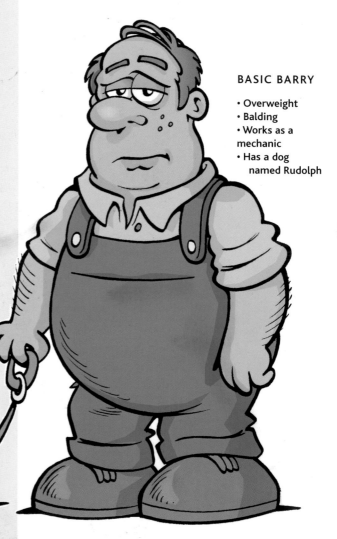

BASIC BARRY
- Overweight
- Balding
- Works as a mechanic
- Has a dog named Rudolph

Brief notes—these are a good start, but if not explored further, will result in a rather flat, uninspiring character.

PRACTICE

The key to learning any skill is to practice, practice, and practice some more. The more you write, the more comfortable and relaxed you will feel when concocting stories, which will enable you to become more diverse and original.

PERSONALIZE IT

When you come to write your own stories, originality will entice an audience in and keep them engrossed, so try to cram in as much of your own personal style as possible.

SIMPLICITY IS THE KEY

The best cartoon characters appear uncomplicated and easy, but more often than not, they are the product of a huge amount of thought and research. The trick is to come up with a highly organized, intricately designed character, and then present that character in a simple, easy to understand manner. It takes a great writer to say something profound simply and eloquently.

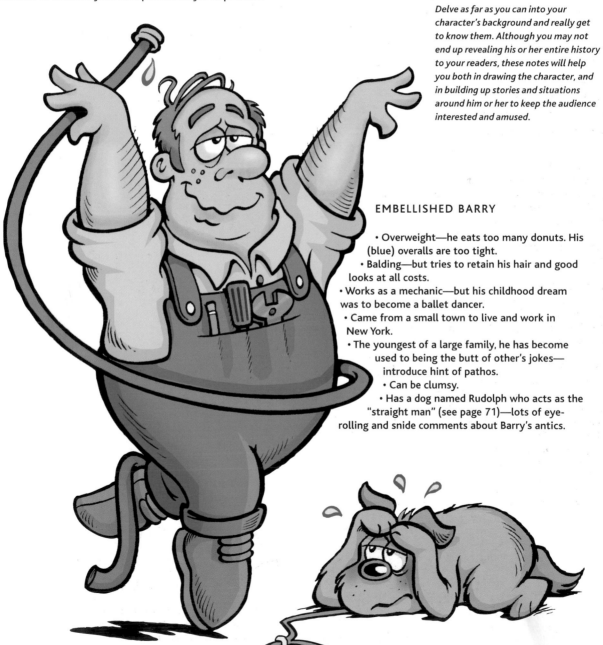

Delve as far as you can into your character's background and really get to know them. Although you may not end up revealing his or her entire history to your readers, these notes will help you both in drawing the character, and in building up stories and situations around him or her to keep the audience interested and amused.

EMBELLISHED BARRY

• Overweight—he eats too many donuts. His (blue) overalls are too tight.

• Balding—but tries to retain his hair and good looks at all costs.

• Works as a mechanic—but his childhood dream was to become a ballet dancer.

• Came from a small town to live and work in New York.

• The youngest of a large family, he has become used to being the butt of other's jokes—introduce hint of pathos.

• Can be clumsy.

• Has a dog named Rudolph who acts as the "straight man" (see page 71)—lots of eye-rolling and snide comments about Barry's antics.

"Clinic 3: Unblocking the Block

Doctor, Doctor! My ideas have dried up! I haven't come up with a brilliant brain wave or cool concept for ages!"

THE DOCTOR WRITES:

"Hmm…It appears you have the dreaded cartoonist's block. It can strike you down at any time, often when you least expect it. Don't worry—the doctor has the remedy for recovery. There are a few simple techniques you can use to conquer the block. First, relax and accept the fact that sometimes ideas will not come while you are worrying about them. Next, walk away from your work for a while and give your mind a rest. While you do that, why not get out and do something completely different? Before you know it, the ideas will be coming thick and fast once more."

SYMPTOMS
- Ideas dried up
- Lack of brain waves
- No inspiration
- Nothing in the ideas bank

Join a library. Books, television, movies, theater, radio, and everyday things you see on the street are all fantastic sources of inspiration, so try to take in a rich, balanced cultural diet.

SEE ALSO
Need further treatment?
See Tutorial 5:
Getting Inspired,
page 22

BE PREPARED FOR DEADLINES
Placing pressure on yourself to come up with ideas can be counterproductive, because you will get frustrated and disheartened when they do not arrive. Some people thrive under the stress of a deadline, but if you find that you dry up, do not leave work until the last moment. There is no telling when ideas are going to flow thick and fast, and when they are going to run dry, so try to relax and go with the flow. Save those ideas for a later date (see Ideas Bank, right).

The mind has a habit of working on a problem while we are preoccupied with something else. Get some exercise or meet with friends, then return to your work refreshed and revitalized.

KEEP AN IDEAS SCRAPBOOK

File your material using a system that works for you. Some cartoonists keep scrapbooks arranged randomly, others file their ideas alphabetically or thematically.

TAKE A BREAK

Leave your work and do something completely different. It is a fact that the human brain has difficulty concentrating on one thing for more than 20 minutes, so if you find yourself stuck at a particular hurdle for a long time, just walk away.

IDEAS BANK

Keep adding to your ideas bank and refer back to it constantly. There may be something buried in there that you have rejected for one project that might be perfect for another.

The Kneebone's Connected to the Thighbone

Now we get to the fun part—creating cartoons!
✚ There is nothing quite like picking up a pencil and venting some pent-up creativity on the unassuming page, bringing your ideas to life, and creating characters that transcend the canvas. ✚ In this chapter we establish the simple rules that define a cartoon drawing and look at the many elements that go into drawing cartoon characters, from shapes and proportions to expressions, actions, and accessories.
✚ The clinics offer troubleshooting advice on a variety of problems, from injecting humor to giving expression to animals. ✚ Use the tutorials in this chapter to guide you, and then practice, practice, practice. ✚ When you use the awesome power of thought to produce something truly eye-catching while simultaneously improving your skills, it is completely engrossing and utterly satisfying.

Next subject please!

TUTORIAL 8

What Makes a Cartoon Character?

Cartoon characters are stylistically unique. Place them alongside any other form of art and they will stand out. So what is it that distinguishes a cartoon from any other piece of artwork? Although there are a wide variety of cartoon styles, characters comply with the same set of rules and customs: The character should be excessively unconventional. It must be comical, well observed, original, and fun. In addition, it should be bright and colorful with bold, dramatic outlines.

Let's take a look at how the cartoon aesthetic differs from a more conventional art form.

CHARACTER

Distortion and simplification are the cartoonist's bread and butter. Often the cartoon is a tiny melodrama in which exaggerated or dramatic features help to put the point across quickly and with the greatest impact. One means of achieving this is to emphasize specific attributes of your character, so that they become, in effect, cartoonist's caricatures, though not necessarily of known persons.

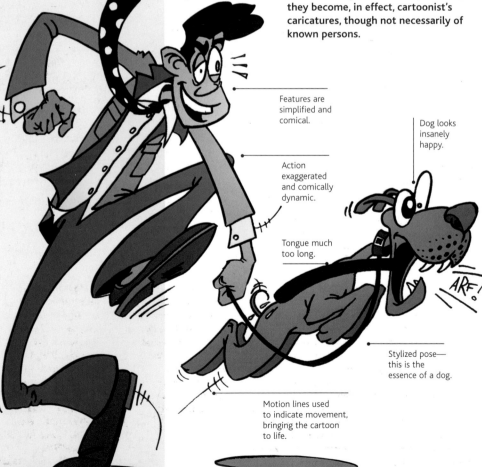

Even the tie takes flight.

Features are simplified and comical.

Action exaggerated and comically dynamic.

Dog looks insanely happy.

Tongue much too long.

Limbs held in extreme positions.

Stylized pose— this is the essence of a dog.

Motion lines used to indicate movement, bringing the cartoon to life.

ARF!

SEE ALSO
Need further treatment?
See Chapter 5:
Adapting Your Style,
pages 112–137

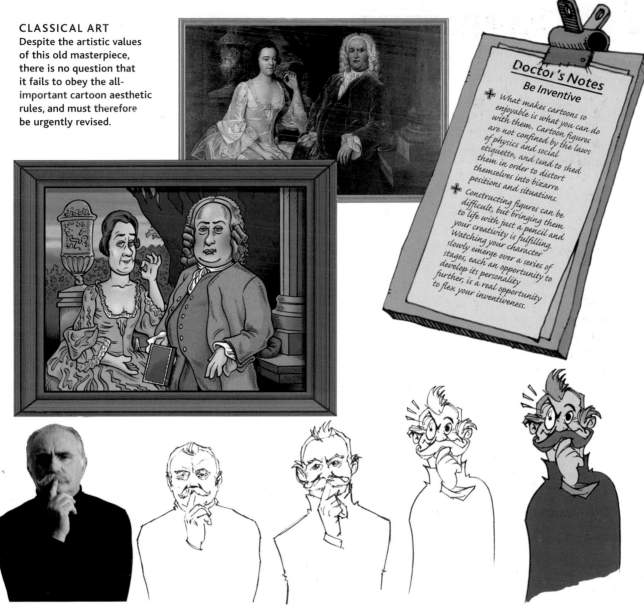

CLASSICAL ART

Despite the artistic values of this old masterpiece, there is no question that it fails to obey the all-important cartoon aesthetic rules, and must therefore be urgently revised.

Doctor's Notes
Be Inventive

+ What makes cartoons so enjoyable is what you can do with them. Cartoon figures are not confined by the laws of physics and social etiquette, and tend to shed them in order to distort themselves into bizarre positions and situations.

+ Constructing figures can be difficult, but bringing them to life with just a pencil and your creativity is fulfilling. Watching your character slowly emerge over a series of stages, each an opportunity to develop its personality further, is a real opportunity to flex your inventiveness.

WHAT IS A CARTOON?

A cartoon should present us with an image we relate to in some way, but it should also be funny. This is the essence of cartoons, and cartoon characters represent the most intimate sort of humorous parody —a parody of us, the viewer.

1 *First, we need to remove unnecessary detail such as color and shade, and reduce the strong edges to outlines. Cartoons rarely employ more detail than necessary. The impact a cartoon character possesses is not dictated by how much detail it contains, but from the way that detail is used— it needs to be simple, striking, and bold.*

2 *Now we come to the most important stage, where we leave reality behind and begin to venture into the realms of the imagination. Expression and physical type are distilled and features are exaggerated.*

3 *The proportions of the entire body are recreated in a much smoother and more rounded way, and rearranged to give the character a less orthodox appearance. The shape of the real human body is intended to fit together nicely, but here we can tweak and modify the dimensions to give them a comical appearance.*

4 *Some clear, bold color finishes the image off well. Beyond the requirement of a novel shape, inked outlines, and bright colors, as an artist you can do whatever you like. If you have trouble recreating a style, try to embrace the things that make your drawing different and develop something more personalized and unique.*

TUTORIAL 9

Boldness Over Realism

You have established that cartoons are unlike any form of conventional art (see pages 34–35). They are certainly not realistic or impressionistic. Cartoon drawing is a way of conveying a concept, rather than a means of capturing a lifelike image, and its success lies in its quickly drawn, high-impact nature. The aim of a cartoonist is to create bold, direct pictures and the way to do this is to draw figures that are well proportioned, but minimally detailed. After the technical stages when you have constructed your figure (see pages 40–45), consider how to represent it with bold and simple design, rather than with lifelike accuracy.

This young girl is drawn with clean lines and simple colors.

BREAKING WITH REALITY

Traditional artists and illustrators may be interested in portraying a person or setting in an approximation of reality. However, a cartoonist's goal is to get a message across in the simplest terms and a realistic portrait would only detract from that. Communicate your ideas clearly and easily with simplified lines, distorted features, and exaggerated situations.

Don't simply draw what you see—contort facial features and simplify wrinkles to a few bold lines.

This character's large nose and stretched spectacles are not supposed to be realistic.

SEE ALSO
Need further treatment?
See Tutorial 8: What Makes a Cartoon Character, page 34

Cartoon plots and settings are also more striking when they are unrealistic and distorted.

This girl's large eyes and long eyelashes are drawn with the minimum of detail, but they still manage to convey her flirtatious qualities.

This guy is all mouth.

The three-fingered hands are a great example of how simplification works over realism in cartooning.

MINIMAL DETAIL

Cutting out detail is part of the simplification process. Notice how the cartoons on this page are drawn with few lines, virtually no shading, and simple blocks of color (known as cell shading). Observe how the line of the ice-skater's pants meets with the skates—smooth, neat, and harmonized. However, simplifying your figures into cartoon form is not just a case of eliminating all detail. Be careful about which details you remove, and which you deem necessary. Any detail you retain should add something to the message you wish to relate—for example, the stripes on this girl's sleeves tell us she likes pretty clothing.

Pants meet skate with barely a wrinkle.

Primary colors, simple sketched lines, and unlikely facial features and joints—yet this cartoon still manages to convey a great deal of emotion.

Simple, smooth outlines allow you to fill out the figure with bold blocks of color.

Notice how this character's clothes splay out at the bottom in smooth curves rather than complicated crinkles and creases.

The lack of detail in his fingers works well, making them appear wormlike and creepy.

Look at how the lines overlap at the knee joint. This gives the leg volume and allows the cartoonist to exaggerate the bend of the joint without distorting the limb.

The horse's mane is drawn with just a few lines. This both fulfills the simplicity of the cartoon aesthetic, and also manages to suggest an older man's balding head.

The shape of this horse has been radically simplified with smooth outlines and cell shading. This has made it much easier for the cartoonist to anthropomorphize the character (see pages 74–75). A few judicious details remain to convey that this horse is rather battered and old.

A horse on two legs? Cartoons allow your imagination free rein.

Doctor's Notes

+ Make sure important parts of a figure are well defined. Clear outlines are essential to define the body, each facial feature, and each item of clothing or accessory.

+ Apart from the above, keep other detail to a minimum. Try to use as few extra lines as you can so your cartoon doesn't look cluttered.

+ Keep your lines rounded and smooth. Material in clothes should not ruffle as it would in real life.

+ Place emphasis on blocks of color rather than fussing over detail, particularly when drawing hair. Teeth can also be represented with blocks of color.

3-D VERSUS 2-D

Unlike much traditional art where a 3-D effect is portrayed with intricate, detailed shading, the 3-D volume in a cartoon creation is suggested with the subtle and clever use of 2-D lines and color. Look at the two images below.

1 This picture clearly follows the right aesthetic rules, and yet it does not look quite right. This is because it is not a cartoon at all, but a 3-D digital model that has had a cartoonlike texture applied to its surface. Its 3-D appearance is achieved with realistic gradient shading.

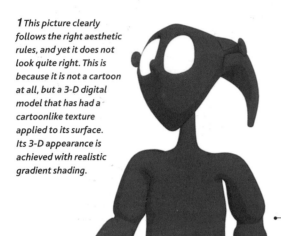

2 This picture has lost all the realistic detail—the lifelike perspective, the skin manipulation at the joints, and most importantly, the 3-D shading effect. A bold outline encloses simple cell shading. Now it looks like a cartoon.

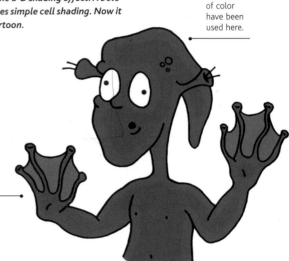

Solid blocks of color have been used here.

The shading, particularly around the joints, gives a 3-D effect.

One small curve in each palm suggests volume in the hands.

ADAPTING ANATOMY

The natural human body and face can be adapted, when drawing cartoons, to create more interesting or comical characters. Distortion is an important tool of the cartoonist, as by simple exaggeration of a body, you can relay a characteristic with speed and impact. Once you know the rules of body proportions (see page 40), you can start to play around and break those rules.

Do *include enough detail to make your character look real (with a good, well-developed structure that shows you know how to draw), but not so much that you let realistic, physical limitations constrict you.*

Don't *go over the top with realism and try to turn your cartoon into a piece of life drawing. Remember, irreverent humor does not work well if it looks like you are trying too hard.*

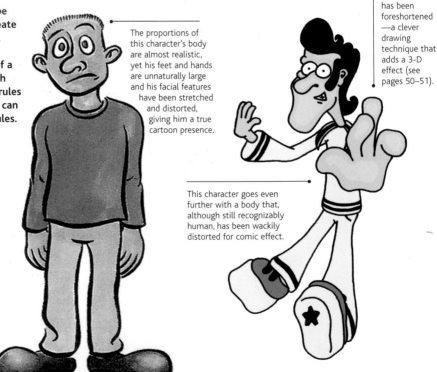

The proportions of this character's body are almost realistic, yet his feet and hands are unnaturally large and his facial features have been stretched and distorted, giving him a true cartoon presence.

His hand has been foreshortened—a clever drawing technique that adds a 3-D effect (see pages 50–51).

This character goes even further with a body that, although still recognizably human, has been wackily distorted for comic effect.

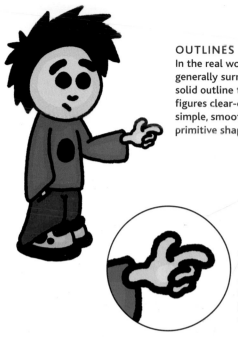

OUTLINES

In the real world, figures and objects are not generally surrounded by a black line, but a dark, solid outline to your cartoon image will keep your figures clear-cut and make colors stand out. Use simple, smooth lines and curves to delineate your primitive shapes (see pages 42–45).

Clean, black curves form this character's features and enclose his hair.

In terms of structure, the hand of this character bears only a slight resemblance to a real hand. Apart from the obvious fact that one finger has been removed for simplicity, the hand is constructed from an extremely simplified set of primitive shapes with a bold, even outline. Notice how the fingers do not taper realistically toward the end, but maintain a consistent thickness rounded off by a simple curve.

COLORS

Use of vibrant color in your cartoons is an excellent way of communicating your message and will make your artwork really stand out. Do not try to replicate colors from the real world; jazz them up, making them cleaner, brighter, and more dazzling.

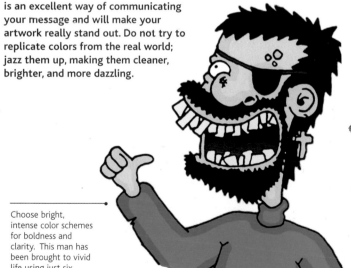

Note that the hair is represented with just one simple color, which is, nonetheless, quite eyecatching.

Choose bright, intense color schemes for boldness and clarity. This man has been brought to vivid life using just six simple colors.

Because you don't need to worry about using gradients of color to represent 3-D volume in your figures, you can usually get away with using just one or two colors for each area. Try to choose shades that are vibrant, even if they are not realistic, such as the bright red tongue and yellow teeth in this illustration (left).

Next subject please!

TUTORIAL 10

SEE ALSO
Need further treatment?
See Tutorial 21:
Figures in Motion, page 76

Easy Figure Construction Methods

For most artists, constructing a figure from scratch is a process of stages. It can be difficult to launch straight into drawing the finished character without any preliminary work. Generally, the first step on the path is to construct a primitive skeleton, so that you can check that your character has the right proportions and stance before you spend time filling in the details.

THE HUMAN SKELETON
A picture of a human skeleton is a handy reference to have around when you are drawing figures because it gives us a good standard for the proportions of any human character.

SIMPLIFIED SKELETON
This simplified skeleton tells us all we need to know about the proportions and position of our character, with none of the unnecessary detail.
Draw one of these diagrams and you will instantly be able to see whether you are happy with your character's proportions.

HUMAN PROPORTIONS
Give your figure the correct human proportions by using these basic estimates of size.

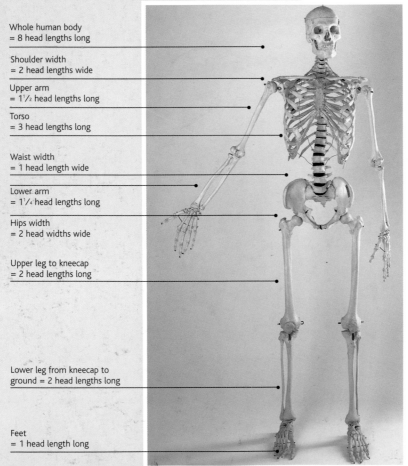

Whole human body
= 8 head lengths long

Shoulder width
= 2 head lengths wide

Upper arm
= 1½ head lengths long

Torso
= 3 head lengths long

Waist width
= 1 head length wide

Lower arm
= 1¼ head lengths long

Hips width
= 2 head widths wide

Upper leg to kneecap
= 2 head lengths long

Lower leg from kneecap to ground = 2 head lengths long

Feet
= 1 head length long

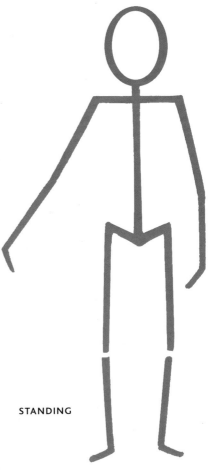

STANDING

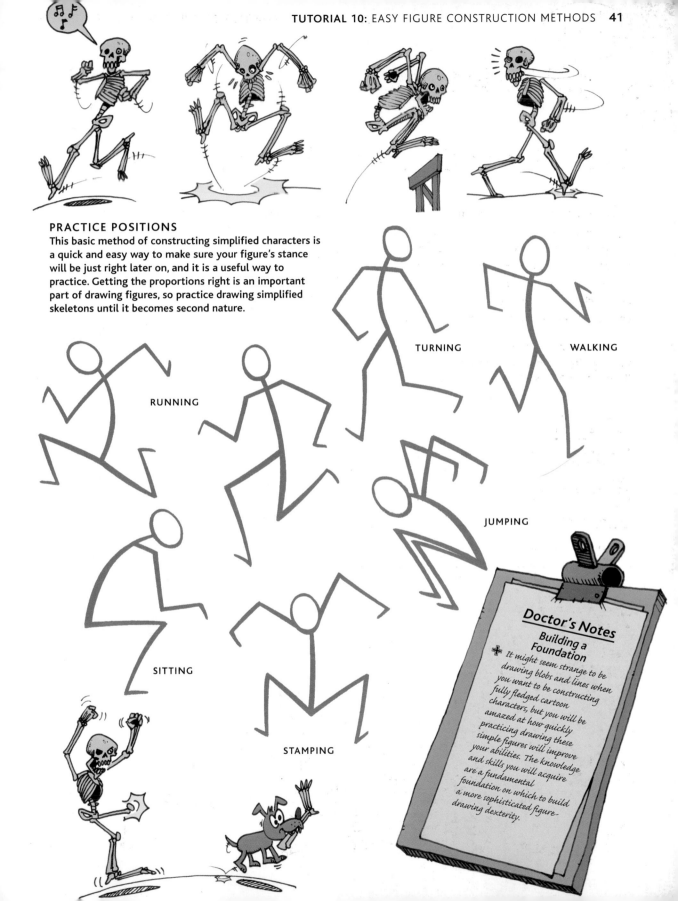

PRACTICE POSITIONS

This basic method of constructing simplified characters is a quick and easy way to make sure your figure's stance will be just right later on, and it is a useful way to practice. Getting the proportions right is an important part of drawing figures, so practice drawing simplified skeletons until it becomes second nature.

TURNING

WALKING

RUNNING

JUMPING

SITTING

STAMPING

Doctor's Notes
Building a Foundation

✚ It might seem strange to be drawing blobs and lines when you want to be constructing fully fledged cartoon characters, but you will be amazed at how quickly practicing drawing these simple figures will improve your abilities. The knowledge and skills you will acquire are a fundamental foundation on which to build a more sophisticated figure-drawing dexterity.

Next subject please!

TUTORIAL 11

Adding Flesh to the Bones

When you are confident drawing a stick figure (as shown on the previous page), the next stage is to add flesh to the bones. To do this, use simple primitive shapes such as cylinders, spheres, and cubes to achieve the desired form. At this stage, refine your figure's proportions until they are exactly what you want—do not be afraid to use your eraser. You are not aiming to create the fully rendered image at this point, so expect it to look slightly unusual.

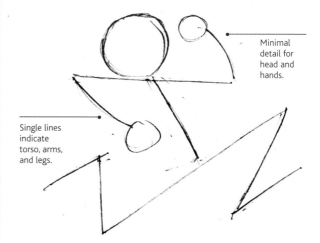

Minimal detail for head and hands.

Single lines indicate torso, arms, and legs.

The sole purpose of these quick and easy stick figures is to give your character some rough skeletal proportions and a pose. The simpler they are the better.

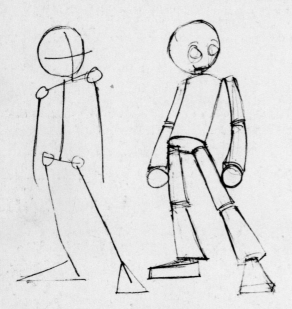

This second stage begins to bring our characters to life— we get a feel for how they look and move.

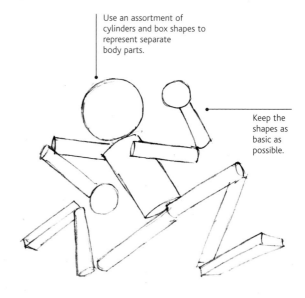

Use an assortment of cylinders and box shapes to represent separate body parts.

Keep the shapes as basic as possible.

Similarly with the fleshed-out version, simplicity is the key. We only need a very rough idea of our figure's dimensions, which will be refined at the next stage.

SEE ALSO
Need further treatment?
See Clinic 4:
Treating 1-D Characters, page 50

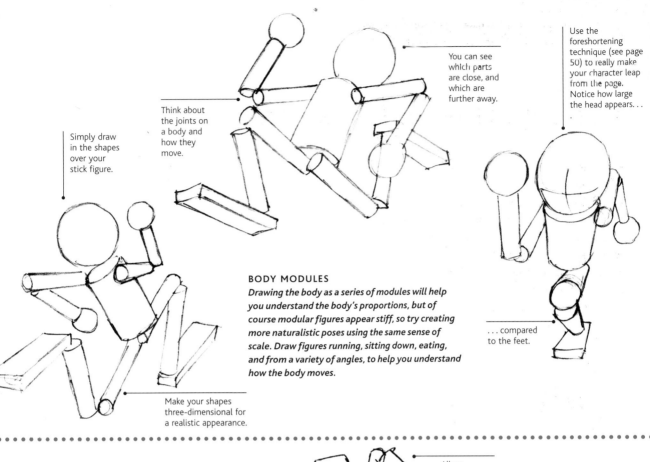

Simply draw in the shapes over your stick figure.

Think about the joints on a body and how they move.

You can see which parts are close, and which are further away.

Use the foreshortening technique (see page 50) to really make your character leap from the page. Notice how large the head appears. . .

. . . compared to the feet.

Make your shapes three-dimensional for a realistic appearance.

BODY MODULES

Drawing the body as a series of modules will help you understand the body's proportions, but of course modular figures appear stiff, so try creating more naturalistic poses using the same sense of scale. Draw figures running, sitting down, eating, and from a variety of angles, to help you understand how the body moves.

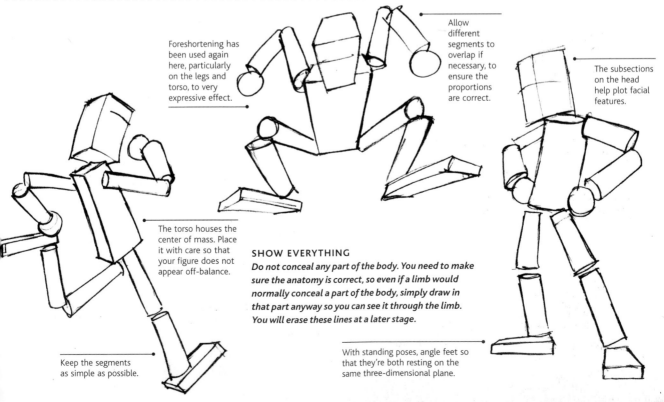

Foreshortening has been used again here, particularly on the legs and torso, to very expressive effect.

Allow different segments to overlap if necessary, to ensure the proportions are correct.

The subsections on the head help plot facial features.

The torso houses the center of mass. Place it with care so that your figure does not appear off-balance.

SHOW EVERYTHING

Do not conceal any part of the body. You need to make sure the anatomy is correct, so even if a limb would normally conceal a part of the body, simply draw in that part anyway so you can see it through the limb. You will erase these lines at a later stage.

Keep the segments as simple as possible.

With standing poses, angle feet so that they're both resting on the same three-dimensional plane.

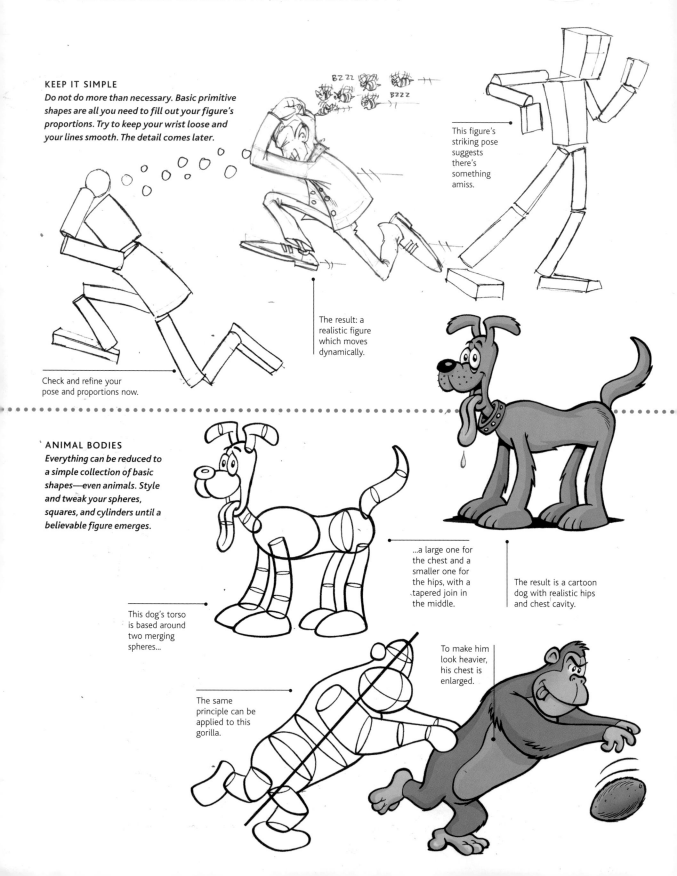

KEEP IT SIMPLE

Do not do more than necessary. Basic primitive shapes are all you need to fill out your figure's proportions. Try to keep your wrist loose and your lines smooth. The detail comes later.

This figure's striking pose suggests there's something amiss.

The result: a realistic figure which moves dynamically.

Check and refine your pose and proportions now.

ANIMAL BODIES

Everything can be reduced to a simple collection of basic shapes—even animals. Style and tweak your spheres, squares, and cylinders until a believable figure emerges.

This dog's torso is based around two merging spheres...

...a large one for the chest and a smaller one for the hips, with a tapered join in the middle.

The result is a cartoon dog with realistic hips and chest cavity.

The same principle can be applied to this gorilla.

To make him look heavier, his chest is enlarged.

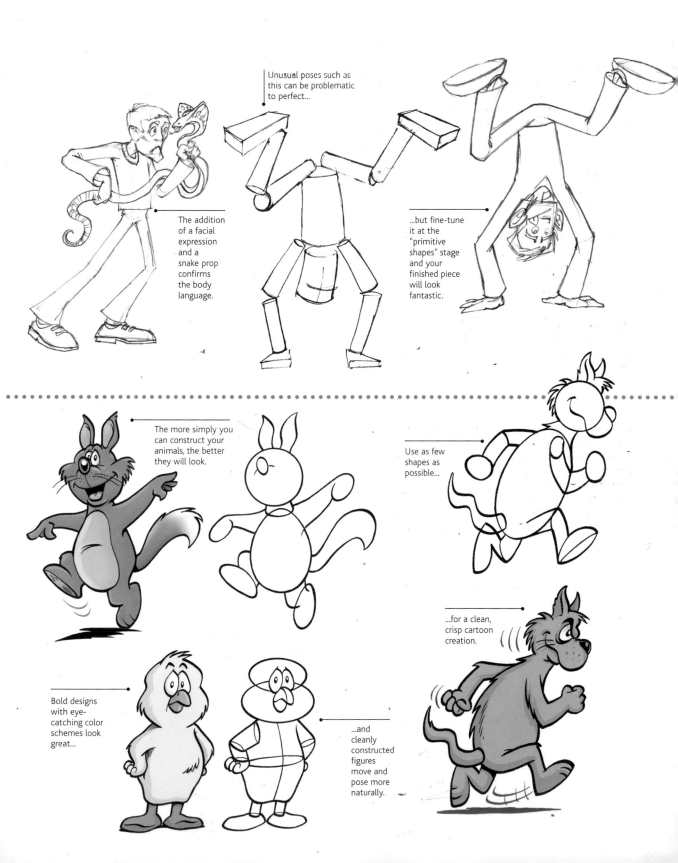

Unusual poses such as this can be problematic to perfect...

The addition of a facial expression and a snake prop confirms the body language.

...but fine-tune it at the "primitive shapes" stage and your finished piece will look fantastic.

The more simply you can construct your animals, the better they will look.

Use as few shapes as possible...

...for a clean, crisp cartoon creation.

Bold designs with eye-catching color schemes look great...

...and cleanly constructed figures move and pose more naturally.

TUTORIAL 12

Human Figure Types

The dimensions of a figure can tell us a lot about its character. Whether we realize it or not, we all harbor certain preconceived opinions about different body types. As cartoonists, we can use these preconceptions to create characters bursting with personality. Although cartoon characters are not restricted by the shackles of what is physically possible, it is useful to be familiar with the three main body types (also called somatotypes): mesomorph, ectomorph, and endomorph.

SEE ALSO
Need further treatment?
See Tutorial 11:
Adding Flesh to the Bones,
page 42

Lots of angles are used, in both body and facial features.

MESOMORPH
The mesomorph has a compact body with shoulders wider than hips. It is the ideal "average" body type and, with certain features exaggerated, is also used for heroic types.

AVERAGE JOE
An average male figure will be between seven and eight heads tall, with shoulders that are slightly wider than the hips. Shoulders are usually two head lengths in width and the distance from hip to toes is four heads. The hands fall mid-thigh.

Smooth curves and soft features are important here.

AVERAGE JOSEPHINE
The average female figure will also be between seven and eight heads tall, although her head will be smaller than that of a male character. In fact, the whole body of a female character is usually drawn slightly smaller. Her hips will be wider in relation to her shoulders, although her hands still fall mid-thigh. Female characters are usually drawn with smoother outlines than male characters.

For a great-looking hero, pump up the muscles, add height, and use sharp, defining lines.

HERO
For a more heroic character, you might want to stretch as far as eight-and-a-half or even nine heads tall, broaden the shoulders, and make the hips much narrower. Heroic characters are generally drawn in a more angular way than normal (this is particularly true with male characters), and their muscles have a much greater size and definition.

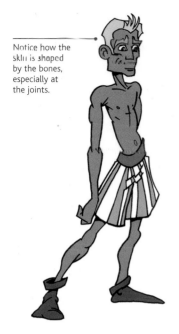

Notice how the skin is shaped by the bones, especially at the joints.

ECTOMORPH

Ectomorphs are light and slender in build with relatively long limbs and small shoulders. For this somatotype, a good knowledge of the skeleton is important, because the skin is stretched over the bones with little cushioning from fat and muscle. This creates a more crooked and angular figure, and is especially noticeable in the hands and feet.

Baggy clothes emphasize a slight figure.

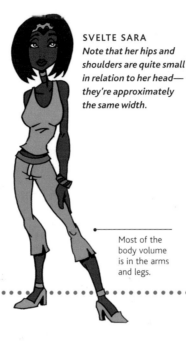

SVELTE SARA
Note that her hips and shoulders are quite small in relation to her head— they're approximately the same width.

SLIM JIM
Ectomorphs have less muscle definition and their lean frames make them appear taller.

Most of the body volume is in the arms and legs.

GYMNASTIC GEOFF
This somatotype is perfect for stamina-based or aerobic sports, so make sure your ectomorph does lots of jumping around!

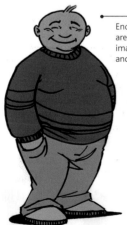

Endomorphs are often less image-conscious and vain.

VOLUPTUOUS VELMA
The endomorphic female figure is easier to draw as the extra volume means smooth lines with no muscle definition.

The majority of the body volume is in the torso.

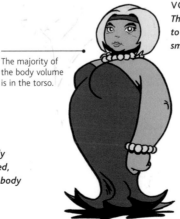

TUBBY TED
Endomorphs are usually slower and more relaxed, and this is reflected by body language and dress.

Think the movement through, planning how the larger areas of fat will be affected before you start.

ENDOMORPH

The heavily built endomorph has a soft, rounded body that has a tendency to become fat, especially around the abdominal area. Endomorphs are usually drawn around five heads tall. They can be more difficult to draw, because their shape is dictated by the way the fat is distributed, and it can vary greatly during movement.

FURIOUS FRANK
Body mass distributes itself differently when endomorphs move, as fat can be affected by secondary motion.

> Next subject please!

TUTORIAL 13

Hands and Hand Gestures

Hands are notoriously difficult to draw, not only because the bone structure is intricate and complicated, but also because they are very expressive. Few cartoon characters stand straight with their hands by their sides, so you will need to know exactly how to draw hands in every position and from every angle to portray all the gesticulating your characters will be doing. Close observation and plenty of practice is the only way to master this subject.

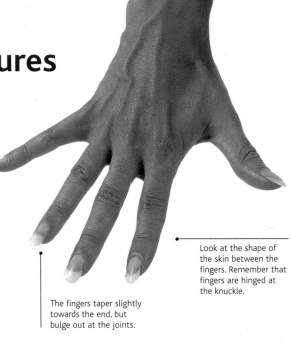

Look at the shape of the skin between the fingers. Remember that fingers are hinged at the knuckle.

The fingers taper slightly towards the end, but bulge out at the joints.

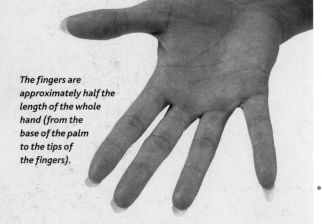

The fingers are approximately half the length of the whole hand (from the base of the palm to the tips of the fingers).

HAND STRUCTURE

In order to draw hands well, it is important to familiarize yourself with the underlying bone structure. There is little fat on hands, and as the bones and joints define the shape, once you know how the bones work together you will be able to draw hands in convincing positions.

CARTOON HANDS

Many cartoon artists make hands easier to draw by removing a finger and making the outlines smoother. You can do this with far more confidence if you have mastered drawing realistic hands first. As a cartoonist, you will not need to be so concerned about realism and intricate detail. It is more important to achieve a smooth, uncomplicated image.

A three-fingered hand is just as expressive as a four-fingered one, and they're easier to draw and coordinate. Just make each finger a bit chunkier.

TIP

Beginners often shy away from including hands in their work, cunningly hiding them in pockets or arranging them carefully out of sight. Hands certainly present a challenge, but this challenge is worth persevering with, because hands are particularly expressive of character and individuality.

SEE ALSO
Need further treatment?
See Tutorial 9: Boldness Over Realism, page 36

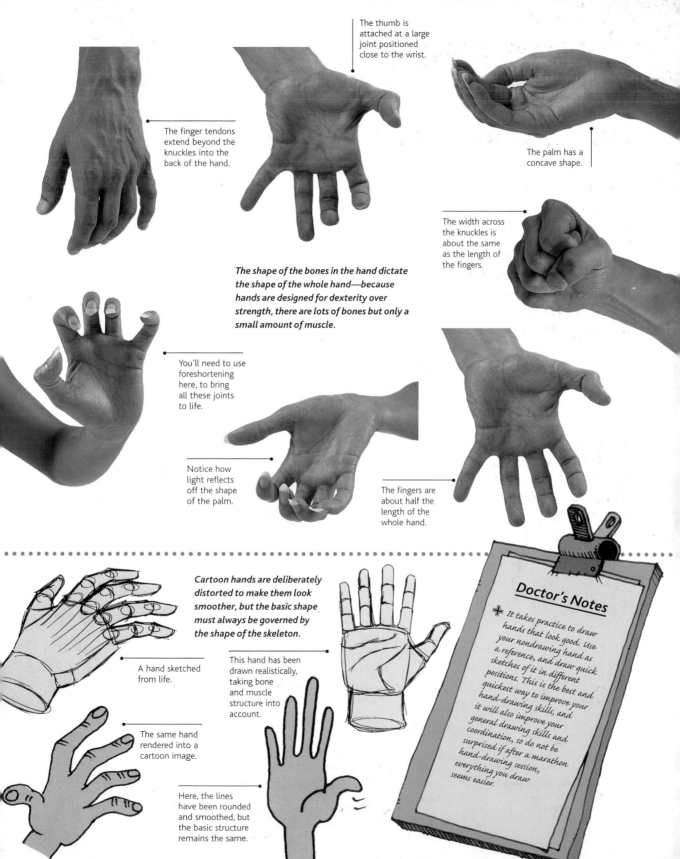

The thumb is attached at a large joint positioned close to the wrist.

The finger tendons extend beyond the knuckles into the back of the hand.

The palm has a concave shape.

The width across the knuckles is about the same as the length of the fingers.

The shape of the bones in the hand dictate the shape of the whole hand—because hands are designed for dexterity over strength, there are lots of bones but only a small amount of muscle.

You'll need to use foreshortening here, to bring all these joints to life.

Notice how light reflects off the shape of the palm.

The fingers are about half the length of the whole hand.

Cartoon hands are deliberately distorted to make them look smoother, but the basic shape must always be governed by the shape of the skeleton.

A hand sketched from life.

This hand has been drawn realistically, taking bone and muscle structure into account.

The same hand rendered into a cartoon image.

Here, the lines have been rounded and smoothed, but the basic structure remains the same.

Doctor's Notes

✚ It takes practice to draw hands that look good. Use a reference, and draw quick sketches of it in different positions. This is the best and quickest way to improve your hand-drawing skills, and it will also improve your general drawing skills and coordination, so do not be surprised if after a marathon hand-drawing session, everything you draw seems easier.

"Clinic 4: *Treating 1-D Characters*

Doctor, Doctor! My characters are flat and lifeless!"

THE DOCTOR WRITES:

"This is an extremely common complaint that can be swiftly treated with the application of a trick called "foreshortening." In Boldness Over Realism (see pages 36–39) we saw that cartooning was not about achieving a perfect and realistic three-dimensional rendition of our characters, but that does not mean we have to draw them flat, as if they were stuck to the page. What we want is a character that reaches out and grabs us, without losing its cartoon style and charm."

SYMPTOMS
- Flat artwork
- One-dimensional looking characters
- Lacks form and depth
- No charisma

FORESHORTENING

This simple technique eliminates any flatness plaguing your pictures, and gives characters more presence. It works on the principle that the nearer something is to our viewpoint, the shorter and larger it appears. This creates depth and the illusion of three dimensions.

Here is a basic cylinder, very much like the cylinders you would use to flesh out your basic skeleton when creating a character.

We have distorted the image, making the area nearer to us bigger and the area further away smaller, so that the cylinder looks more three-dimensional. Now we have a cylinder that is bursting off the paper in a dynamic and exciting way.

SEE ALSO
Need further treatment?
See Tutorial 11:
Adding Flesh to the Bones,
page 42

Making the top of this rectangular shape larger than the bottom gives the impression of an aerial view.

The second tube has been foreshortened, resulting in a more organic, livelier feel.

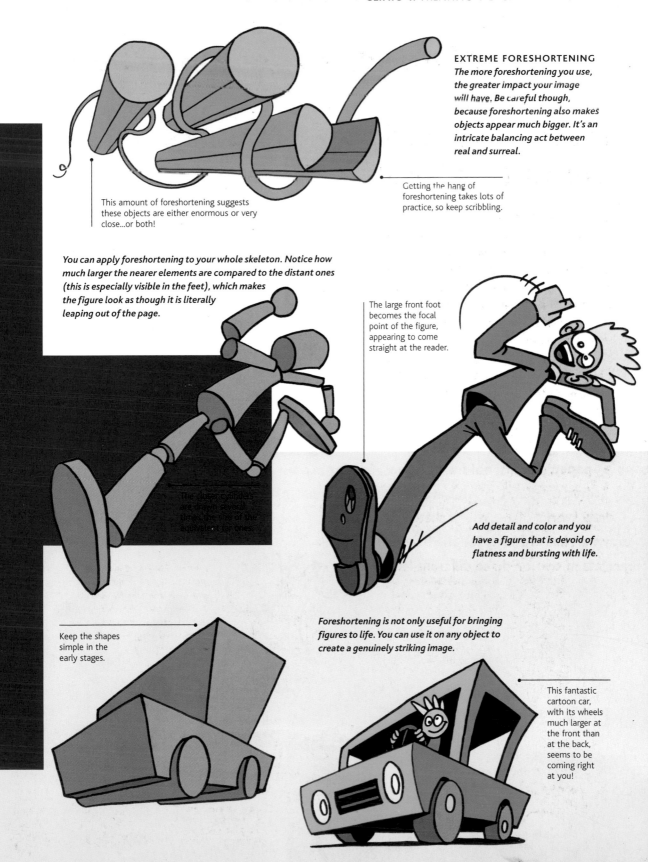

EXTREME FORESHORTENING
The more foreshortening you use, the greater impact your image will have. Be careful though, because foreshortening also makes objects appear much bigger. It's an intricate balancing act between real and surreal.

This amount of foreshortening suggests these objects are either enormous or very close...or both!

Getting the hang of foreshortening takes lots of practice, so keep scribbling.

You can apply foreshortening to your whole skeleton. Notice how much larger the nearer elements are compared to the distant ones (this is especially visible in the feet), which makes the figure look as though it is literally leaping out of the page.

The large front foot becomes the focal point of the figure, appearing to come straight at the reader.

The closer cylinders are drawn several times the size of the equivalent far ones.

Add detail and color and you have a figure that is devoid of flatness and bursting with life.

Keep the shapes simple in the early stages.

Foreshortening is not only useful for bringing figures to life. You can use it on any object to create a genuinely striking image.

This fantastic cartoon car, with its wheels much larger at the front than at the back, seems to be coming right at you!

Next subject please!

TUTORIAL 14

Building Cartoon Heads and Faces

Building cartoon heads is an intricate and delicate business. Not only do you have to bring together a sophisticated collection of detailed features and place them in exactly the right location, you must also arrange them in precisely the right way to form the desired expression.

It can be a complicated feat of coordination but if you break the process down into the stages described here, you will find it straightforward.

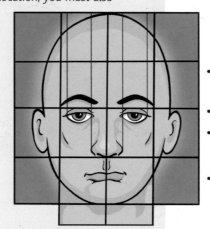

HUMAN HEAD PROPORTIONS

There are some simple rules to follow when you draw the human head that will ensure that all the features are in the correct position and proportion.

The width of the head is usually equivalent to about five eyes, with one eye width separating the eyes.

The eyes fall approximately halfway between the top of the skull and the base of the chin.

The ears are positioned slightly lower, in line with the nose. The nose should reach from the eyes to about three-quarters of the way down the head.

The mouth is situated just over an eighth of the way up the head (slightly closer to the base of the nose than to the chin). The width of the mouth can be calculated by drawing an equilateral triangle starting at the top of the nose and in line with the outside edges of the nostrils. When the lines reach the horizontal location of the mouth, the triangle's two long sides should meet with the edges of the mouth.

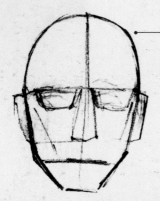

The head is thicker at the top, so that the dome of the skull appears semi-circular from the front, whereas the chin tends to taper.

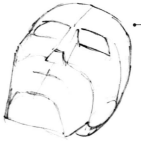

The eyes sit back inside the skull (below the brow), while all the other features rest outside it.

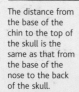

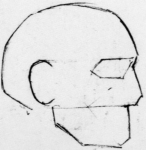

The distance from the base of the chin to the top of the skull is the same as that from the base of the nose to the back of the skull.

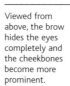

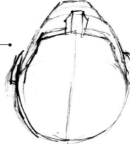

Viewed from above, the brow hides the eyes completely and the cheekbones become more prominent.

PRACTICE THE ELEMENTALS

This simplified model of a head is similar to our simplified skeletons (see pages 40–41), which we used in the first stage of building up a figure. In the same way, the simplified head is perfect to practice. Draw it from as many angles as you can to build up your familiarity and expertise with its shape and form. Once you have mastered this easy standard, you can adapt it into any type of head.

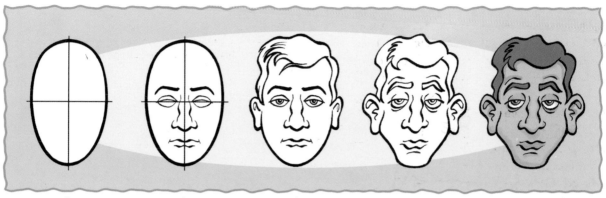

Begin with a simple oval outline and guides.

Plot the basic features on the guides.

Add ears and a distinguishing hairstyle.

Fine-tune your lines to add character to the face.

Add color and shading... and *voilà*!

FEMALE

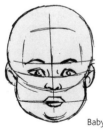

Baby

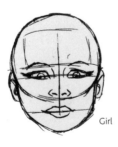

Girl

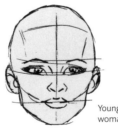

Young woman

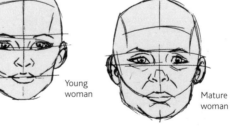

Mature woman

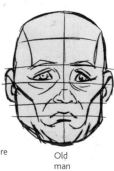

Old woman

HOW THE FACIAL FEATURES CHANGE WITH AGE AND GENDER
These drawings show some basic differences. A child's forehead is high, the nose very small and unformed. Young people have firm features and often rounded, "puppy-fat" flesh, but with age, bones and muscles are more visible. In men, the jaw and brow are typically heavier than in women. With increasing age, the skin begins to pouch and fold downward.

MALE

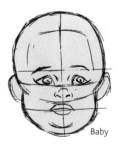

Baby

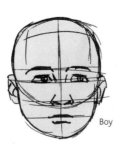

Boy

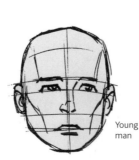

Young man

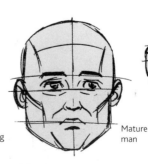

Mature man

Old man

DIFFERENT ANGLES

Once you've got the hang of the basic techniques, it's time to start sketching more detailed faces from every conceivable angle. This takes lots of practice, so don't give up if you don't draw perfect faces straight away.

MALE

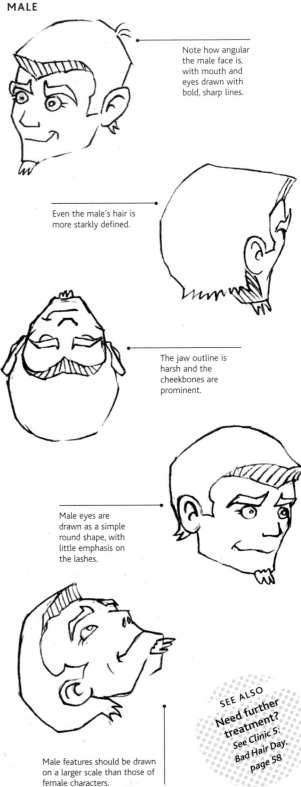

Note how angular the male face is, with mouth and eyes drawn with bold, sharp lines.

FEMALE

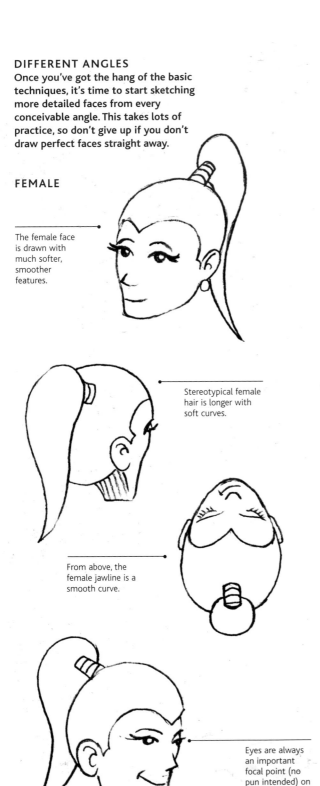

The female face is drawn with much softer, smoother features.

Even the male's hair is more starkly defined.

Stereotypical female hair is longer with soft curves.

The jaw outline is harsh and the cheekbones are prominent.

From above, the female jawline is a smooth curve.

Male eyes are drawn as a simple round shape, with little emphasis on the lashes.

Eyes are always an important focal point (no pun intended) on the female face with curved lines and long lashes.

Male features should be drawn on a larger scale than those of female characters.

SEE ALSO
Need further treatment?
See Clinic 5:
Bad Hair Day,
page 58

EXCEPTIONS TO THE RULES

Once you have learned the techniques described here, you should find it easy to draw cartoon heads in a range of styles. However, some cartoonists are so familiar with specific styles that they prefer to draw their characters in their own way.

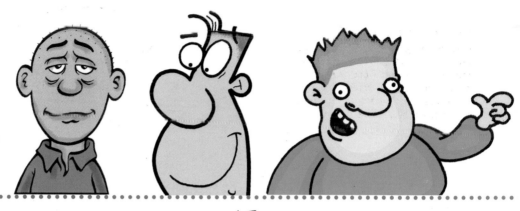

ANIMAL HEADS

Animal heads can be built in much the same way as animal bodies, by breaking them down into basic shapes (see pages 72–73). Build up the head using circles, ovals, and lines before adding more detail. Real-life animals often have very impassive faces that reveal little character. Therefore, the heads and faces of cartoon animals are often drawn with human characteristics to make them more expressive. Notice that the animals on this page have smiling mouths and large, animated eyes. This technique is known as anthropomorphism—see more on pages 74–75.

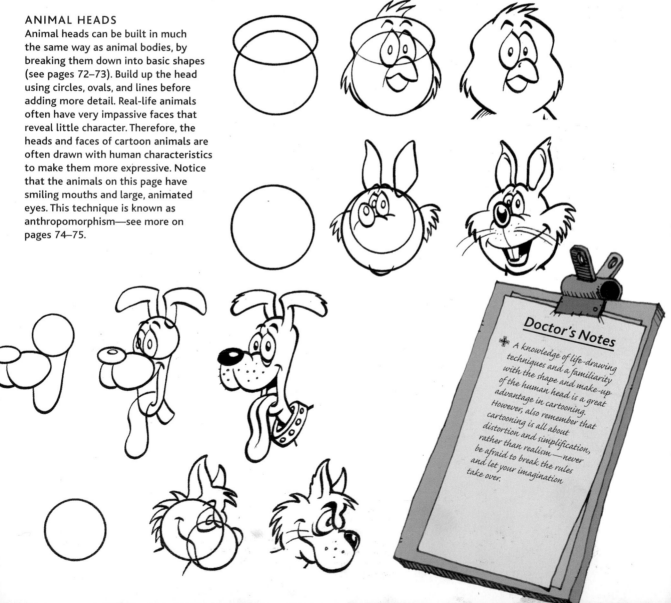

Doctor's Notes

✚ A knowledge of life-drawing techniques and a familiarity with the shape and make-up of the human head is a great advantage in cartooning. However, also remember that cartooning is all about distortion and simplification, rather than realism—never be afraid to break the rules and let your imagination take over.

Next subject please!

TUTORIAL 15

Capturing Expression

A face can tell you so much about a person. Not only whether he or she is young or old, pretty or ugly, but often whether they are aggressive or timid, stupid or clever. It reveals a range of feelings. Before we get to know a person, we will judge them on their appearance alone.

The cartoonist must take advantage of this human reaction and use particular facial features and types to create their characters. A businessman will be plump and balding; a hippie will have long hair, a thin face, and small, round glasses. Corny stereotypes, but instantly recognizable.

A glance at any chance group of humans will remind you of the discrepancies between facial features. Get used to observing people in the street and use your sketchbook to record unusual, as well as typical, characteristics.

SEE ALSO
Need further treatment?
See Tutorial 20:
Drawing Animals,
page 73

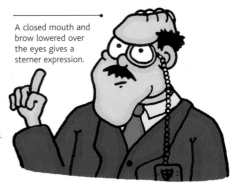

Notice how much the features open up when a character is surprised; not only his mouth, but his eyes, eyebrows, nose, and hair too!

The more extreme the emotion, the more contorted the features.

A wide smile and upturned face give this youngster a happy-go-lucky, unselfconscious air.

A closed mouth and brow lowered over the eyes gives a sterner expression.

AGE
You will notice certain facial characteristics associated with age. A very young child's features are crowded into the center of the face. A child's head is larger in proportion to his or her body than is an adult's. An elderly person will often be smaller in stature, have a bigger nose, and hollow cheeks.

Screwed-up features, with a downturned mouth and severe forehead wrinkles bringing the eyes together, indicate an angry, unpleasant personality.

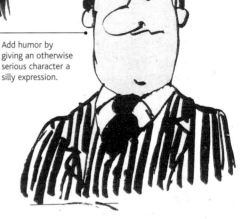

The upward-looking eyes and unsmiling mouth display melancholy.

Add humor by giving an otherwise serious character a silly expression.

EXPRESSION

The point of a cartoon is often made through facial expression. You cannot afford to let the reader miss the point, so your depiction of an inner feeling will need to be exaggerated—a caricature of what it is in reality. A drunk, for example, can be depicted with concentric circles for eyes and an undulating line for a mouth.

Conversely, this dopey character, with his teeth hanging out, is making an amusing attempt to appear sophisticated with his necktie and lowered brow.

COLLECTING EXAMPLES

You are your best model in this case. You will need to study yourself in a mirror, contorting your face into various expressions. See what your eyes and mouth in particular are up to when you laugh, are angry, or frightened. Start by doing some quick sketches to capture the essence of each expression, then transfer them to some of the characters you have created. You will find certain expressions seem to suit certain characters—another facet of the stereotype.

On a glum face, all the features seem to hang downward.

Use the hair to extend the facial expression in instances of extreme alarm.

One expression you will have to study if you are interested in verbal jokes is the talking face. Who is it who is making the punchline? This needs to be obvious and it is the open speaking mouth which can lead the eye to the center of the action.

Clinic 5: Bad Hair Day

"Doctor, Doctor! I'm pulling my hair out! I just can't get my head around locks, fur, tresses, beards, or curls."

THE DOCTOR WRITES:

"Don't worry! Like everything in cartooning, it is all perfectly simple if you look at it the right way. In the real world, people take their hair very seriously. This is primarily because our hair says a lot about who we are. A person's hair can tell you about his or her cultural background, levels of masculinity or femininity, and fashion sensibility. It is similar to carrying a big sign around on our head telling people what we are like. As a cartoonist, you can exploit this and use your character's hair to reveal his or her personality."

SYMPTOMS
- Hair looks the same on all characters
- Boring hairstyles
- Hair doesn't add to personality
- Even beards look bad

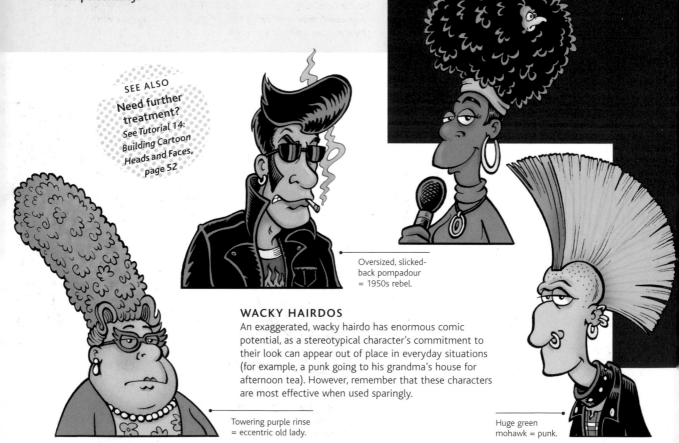

SEE ALSO
Need further treatment?
See Tutorial 14: Building Cartoon Heads and Faces, page 52

Oversized, slicked-back pompadour = 1950s rebel.

WACKY HAIRDOS

An exaggerated, wacky hairdo has enormous comic potential, as a stereotypical character's commitment to their look can appear out of place in everyday situations (for example, a punk going to his grandma's house for afternoon tea). However, remember that these characters are most effective when used sparingly.

Towering purple rinse = eccentric old lady.

Huge green mohawk = punk.

Straight hair tied back = self-controlled/icy.

Crazy curls = bubbly and lively.

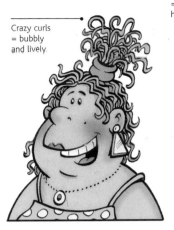

Unkempt and long = fatigued/haggard.

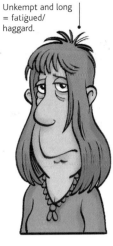

Long and styled = sophisticated, sometimes malevolent.

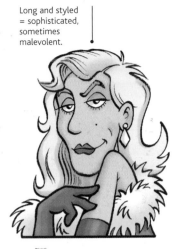

Sensibly pulled back hair gives this accountant a conservative appearance.

Note how thick each strand of hair is—clear outlines with visible color fills are necessary, so don't give hair realistic proportions.

This long, lank, lifeless hair has been drawn as a solid block of color with a few simple line details to highlight.

This stylized hair is both simply drawn and exaggerated.

WHAT YOUR HAIR SAYS ABOUT YOU

A distinctive hairstyle is a great way to extend the theme of a character—it gives additional information as to the character's personality. When you've decided who you want your characters to be, try to imagine how they would style their hair before you put pencil to paper. Are they pretentious, scruffy, or just plain nuts?

Slicked back with one free curl at front = superhero look.

Wavy, shaggy hair curling around ears = romantic.

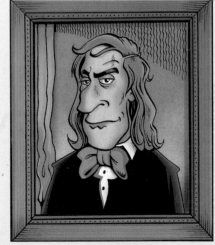

Short, slicked back, clipped sideburns = brooding/stylish.

Bald head and beard = intellectual, sometimes sinister.

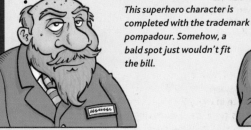

This superhero character is completed with the trademark pompadour. Somehow, a bald spot just wouldn't fit the bill.

The neat, prescribed appearance of this gentleman's hair suits his formal attire.

This character has chosen a glossy, stylish "do" for himself—he obviously has a high opinion of his looks.

Next subject please!

TUTORIAL 16

SEE ALSO
Need further treatment?
See Tutorial 23: Bringing It All Together, page 84

How to Dress Your Character

Clothing provides a great opportunity for the cartoonist to define a character. In real life we have different clothes for different occasions. In a cartoon sketch, you can use clothing to set a scene. For instance, beachwear or formal wedding attire will provide context without the necessity of any other props. Clothing can also be used to reveal a character's interests or work, as well as fashion sense and musical preferences. Think about your character's clothing and explore whether different styles can enhance a creative idea.

WHAT TO WEAR
Clothing helps us to communicate with our audience about a character. We assume that people who dress well have self-confidence and pride in themselves, whereas people who dress with no effort are perceived to have low self-esteem. Clothes can show creativity or the desire to be like everyone else. Colors in clothes can be used to show mood—bright colors suggest a character is happy and buoyant, whereas dark colors suggest seriousness and even sadness.

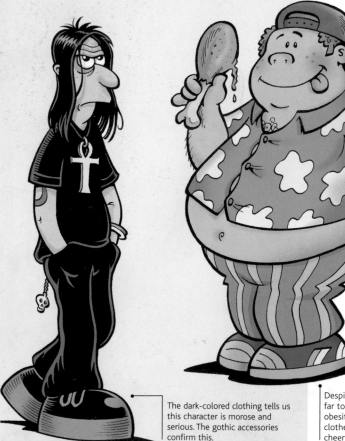

These plain and simple clothes show that this character values comfort over style.

The dark-colored clothing tells us this character is morose and serious. The gothic accessories confirm this.

Despite the fact that they are far too small and highlight his obesity, these bright-colored clothes give this character a cheerful appearance.

TRADEMARK CLOTHES

Many popular cartoon characters wear the same outfit whatever they are doing. Audiences like the familiarity and uniformity of a character who always dresses the same. If you are interested in taking your characters on a number of adventures, you might want to consider giving them a trademark look. Here are a few tips:

■ *Choose something timeless—if you dress your characters in something contemporary, they will eventually look dated.*

■ *You will want to choose something that makes a statement about your character, but this does not mean it has to be crazy or impractical. Choose something that gently reinforces your character's image.*

■ *Trademark clothing only works when it is original, so try not to be influenced by other cartoonists.*

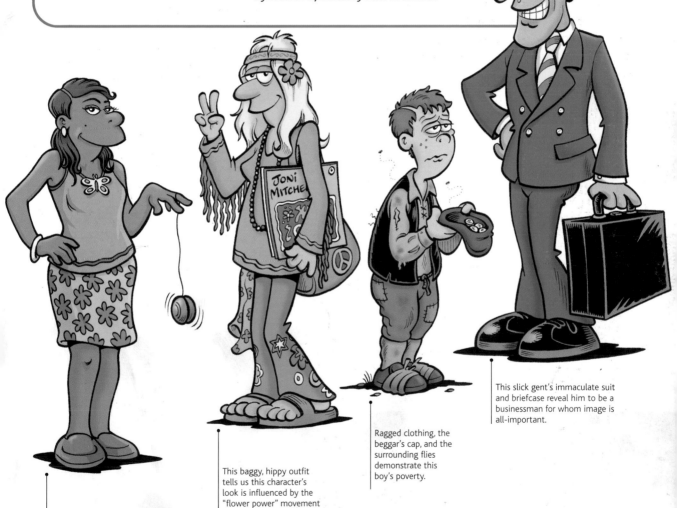

This slick gent's immaculate suit and briefcase reveal him to be a businessman for whom image is all-important.

Ragged clothing, the beggar's cap, and the surrounding flies demonstrate this boy's poverty.

This baggy, hippy outfit tells us this character's look is influenced by the "flower power" movement of the 1960s.

Youthful, colorful clothing suggests this character is fun loving and fancy free. The yo-yo says it all!

Next subject please!

TUTORIAL 17

Useful Accessories

Accessories help to define a character and can increase its comic potential. Old favorites such as a banana skin can hint toward an imminent disaster, while others, a magic wand for instance, will make a story more exciting. In fact, props and accessories generally fall into one of three categories: character props, which tell us more about an individual; comedic props, which are there for humor; and story props, which help to push forward a plot.

Grabber arm

Fancy glasses

Mobile phone

Magic wand

Jumbo horn-rimmed specs

What do the flashy glasses, groovy tie, and massive platform shoes tell us about this character? Props incite intrigue in our audience by making a character different and interesting…often with bucketloads of scope for hilarity.

Oversized polka-dot tie

SEE ALSO
Need further treatment?
See Tutorial 16: How to Dress Your Character, page 60

Whopping platform shoes

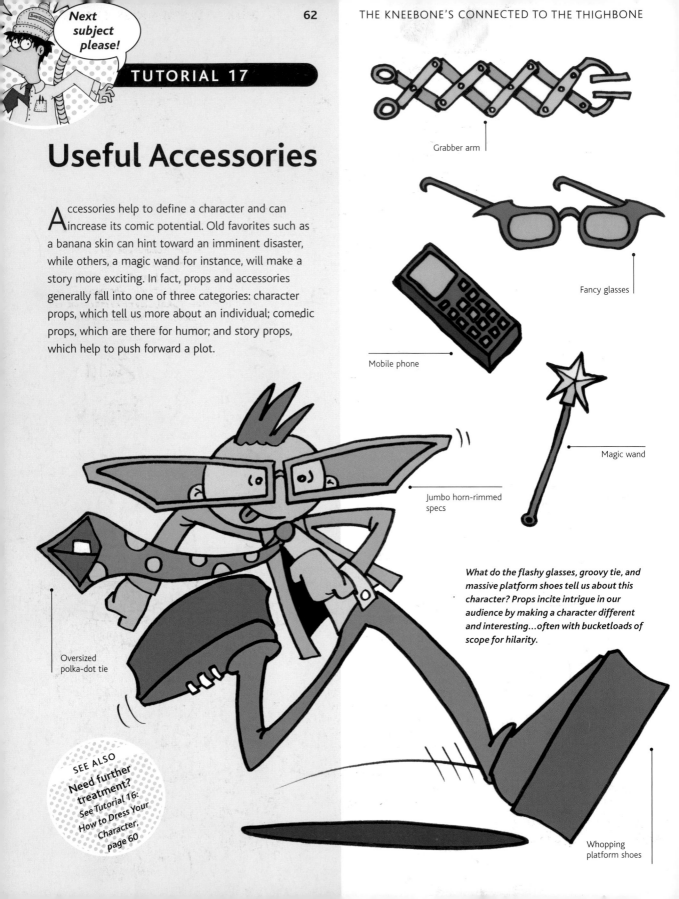

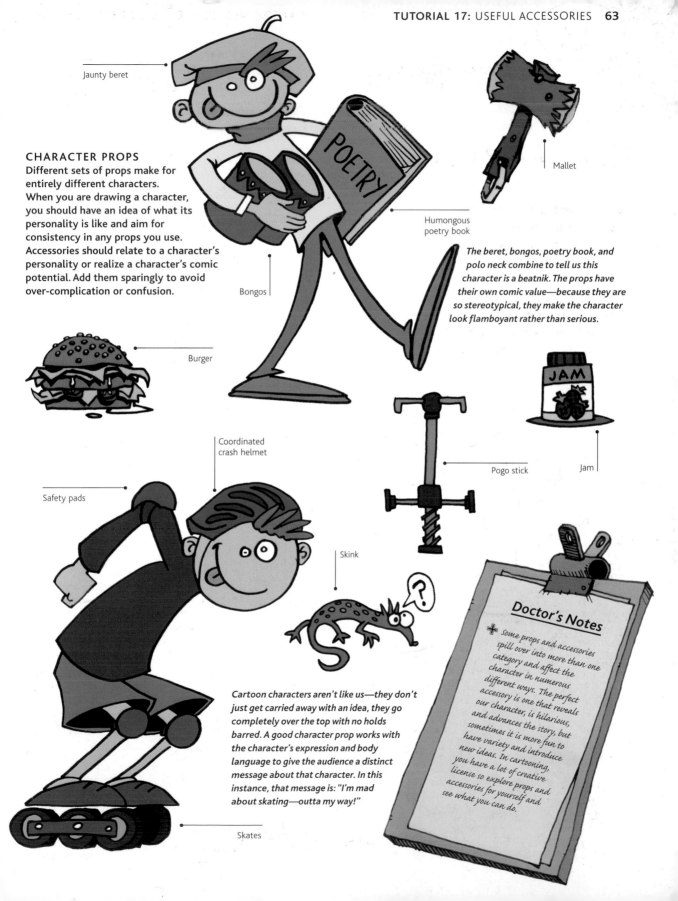

Jaunty beret

Mallet

CHARACTER PROPS

Different sets of props make for entirely different characters. When you are drawing a character, you should have an idea of what its personality is like and aim for consistency in any props you use. Accessories should relate to a character's personality or realize a character's comic potential. Add them sparingly to avoid over-complication or confusion.

Humongous poetry book

The beret, bongos, poetry book, and polo neck combine to tell us this character is a beatnik. The props have their own comic value—because they are so stereotypical, they make the character look flamboyant rather than serious.

Bongos

Burger

Coordinated crash helmet

Safety pads

Pogo stick

Jam

Skink

Cartoon characters aren't like us—they don't just get carried away with an idea, they go completely over the top with no holds barred. A good character prop works with the character's expression and body language to give the audience a distinct message about that character. In this instance, that message is: "I'm mad about skating—outta my way!"

Skates

Doctor's Notes

✚ Some props and accessories spill over into more than one category and affect the character in numerous different ways. The perfect accessory is one that reveals our character, is hilarious, and advances the story, but sometimes it is more fun to have variety and introduce new ideas. In cartooning, you have a lot of creative license so explore props and accessories for yourself and see what you can do.

QUACK SQUONK

YIKES! ARGF! GERROFF!

Good comedy props play on people's worst fears of embarrassment.

Giant weight

1 BILLION TONNES

COMEDY PROPS

When you use comedy props, the humor should be in the character's reaction to the prop rather than in the prop itself, so you need to do some character development first. These types of jokes always work best when they take the audience by surprise, so try to keep it fresh and original.

Garden rake

Custard

VAT OF CUSTARD

Use a prop to provoke an hilarious reaction.

Never work with children or animals—except when cartooning, of course, when they can give rise to some really funny situations. Here, the reactions of boy and bird complement each other to great comic effect.

Despite its potentially violent nature, this prop works as a comic device because of the implausible injury it causes.

Anchor

Sometimes it works for your character to be in on the gag.

Character's reactions are physical as well as psychological. Here, the character's physical reaction (the way his trapped leg has turned to jelly) is as significant as his emotional reaction (made clear by his facial expression and body language).

Squirting flower

ACID

??

These absurdly oversized teeth are funny, not only because of the way they alter the character's appearance, but also because of the hyperactive behavior they appear to be inciting in the character.

Skink number two

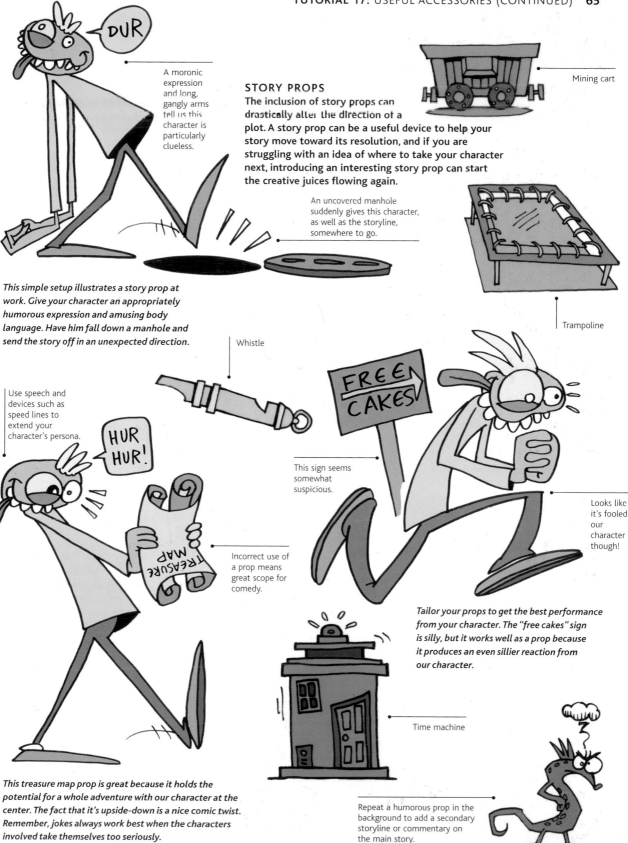

A moronic expression and long, gangly arms tell us this character is particularly clueless.

Mining cart

STORY PROPS

The inclusion of story props can drastically alter the direction of a plot. A story prop can be a useful device to help your story move toward its resolution, and if you are struggling with an idea of where to take your character next, introducing an interesting story prop can start the creative juices flowing again.

An uncovered manhole suddenly gives this character, as well as the storyline, somewhere to go.

This simple setup illustrates a story prop at work. Give your character an appropriately humorous expression and amusing body language. Have him fall down a manhole and send the story off in an unexpected direction.

Trampoline

Whistle

Use speech and devices such as speed lines to extend your character's persona.

This sign seems somewhat suspicious.

Looks like it's fooled our character though!

Incorrect use of a prop means great scope for comedy.

Tailor your props to get the best performance from your character. The "free cakes" sign is silly, but it works well as a prop because it produces an even sillier reaction from our character.

Time machine

This treasure map prop is great because it holds the potential for a whole adventure with our character at the center. The fact that it's upside-down is a nice comic twist. Remember, jokes always work best when the characters involved take themselves too seriously.

Repeat a humorous prop in the background to add a secondary storyline or commentary on the main story.

Next subject please!

TUTORIAL 18

SEE ALSO
Need further treatment?
See Tutorial 21: Figures in Motion, page 79

Using Cartoon Devices

Cartoons use a large number of conventions that act as a sort of shorthand for conveying actions, noises, or states of mind. They are part of the comedy of exaggeration, making things visible that are not physically present.

One of the best-known and most obvious devices are speed lines, trailing out from people's feet when they are running or from car or bicycle wheels. There are variations on this—sometimes the speed is shown just by straight lines, which give a whizzing effect; you can also use little puffs of smoke, suggesting that the character is burning up the road by running so fast; or to show that a long distance has been covered, the lines might meander broadly to add the extra length within the shallow pictorial space.

Other devices include short, sharp lines coming out of a dog's mouth to indicate an ear-splitting bark, and huge beads of sweat breaking from a face to convey enormous anxiety or effort. The sweating is disproportionate—you don't normally see great droplets flying off anxious people—and that is part of the gag. By contrast, the light bulb going on over somebody's head to show a great idea suddenly dawning is associative rather than exaggerated.

These examples are familiar, and we have learned to read them the right way. However, there is room for some new ideas of your own.

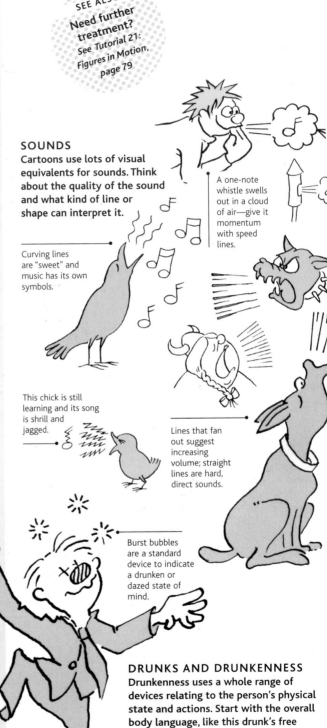

SOUNDS
Cartoons use lots of visual equivalents for sounds. Think about the quality of the sound and what kind of line or shape can interpret it.

Curving lines are "sweet" and music has its own symbols.

A one-note whistle swells out in a cloud of air—give it momentum with speed lines.

This chick is still learning and its song is shrill and jagged.

Lines that fan out suggest increasing volume; straight lines are hard, direct sounds.

Burst bubbles are a standard device to indicate a drunken or dazed state of mind.

DRUNKS AND DRUNKENNESS
Drunkenness uses a whole range of devices relating to the person's physical state and actions. Start with the overall body language, like this drunk's free but unsteady movement.

Movement lines do not always show speed—this is a slow, weaving path.

The double line on the shoe soles gives him an unstable base.

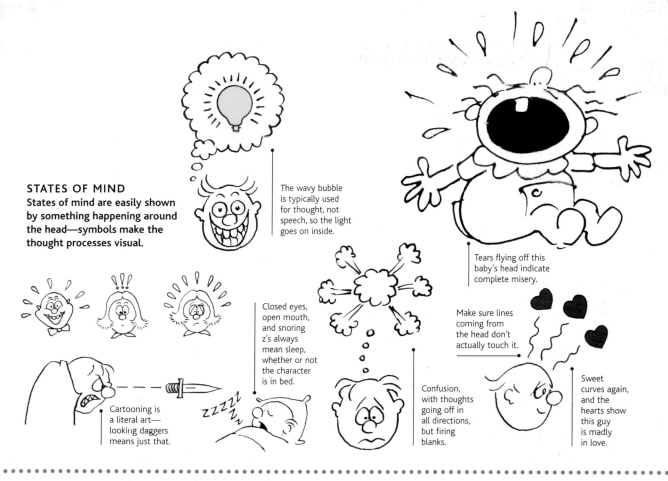

STATES OF MIND

States of mind are easily shown by something happening around the head—symbols make the thought processes visual.

The wavy bubble is typically used for thought, not speech, so the light goes on inside.

Tears flying off this baby's head indicate complete misery.

Closed eyes, open mouth, and snoring z's always mean sleep, whether or not the character is in bed.

Make sure lines coming from the head don't actually touch it.

Cartooning is a literal art—looking daggers means just that.

Confusion, with thoughts going off in all directions, but firing blanks.

Sweet curves again, and the hearts show this guy is madly in love.

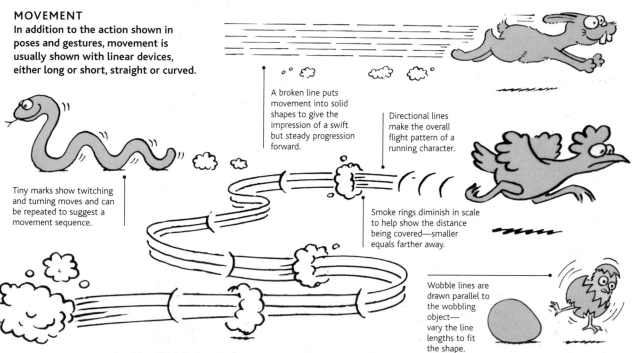

MOVEMENT

In addition to the action shown in poses and gestures, movement is usually shown with linear devices, either long or short, straight or curved.

A broken line puts movement into solid shapes to give the impression of a swift but steady progression forward.

Directional lines make the overall flight pattern of a running character.

Tiny marks show twitching and turning moves and can be repeated to suggest a movement sequence.

Smoke rings diminish in scale to help show the distance being covered—smaller equals farther away.

Wobble lines are drawn parallel to the wobbling object—vary the line lengths to fit the shape.

TUTORIAL 19

Making Speech Bubbles Work for You

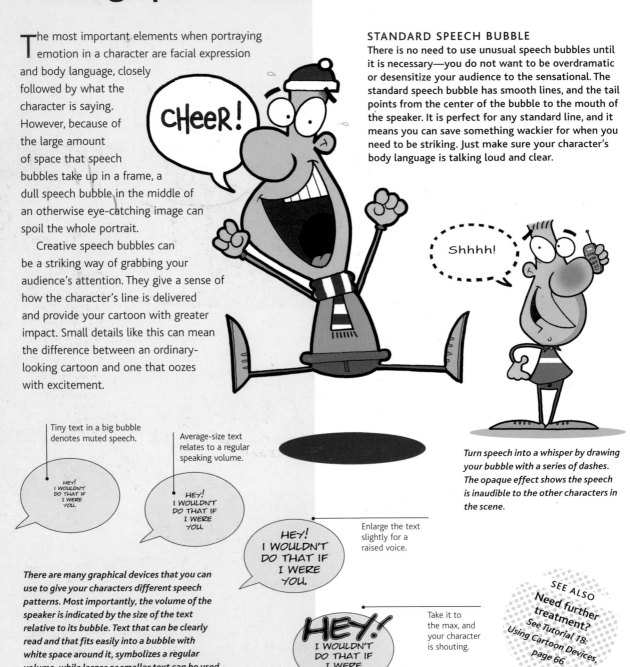

The most important elements when portraying emotion in a character are facial expression and body language, closely followed by what the character is saying. However, because of the large amount of space that speech bubbles take up in a frame, a dull speech bubble in the middle of an otherwise eye-catching image can spoil the whole portrait.

Creative speech bubbles can be a striking way of grabbing your audience's attention. They give a sense of how the character's line is delivered and provide your cartoon with greater impact. Small details like this can mean the difference between an ordinary-looking cartoon and one that oozes with excitement.

STANDARD SPEECH BUBBLE

There is no need to use unusual speech bubbles until it is necessary—you do not want to be overdramatic or desensitize your audience to the sensational. The standard speech bubble has smooth lines, and the tail points from the center of the bubble to the mouth of the speaker. It is perfect for any standard line, and it means you can save something wackier for when you need to be striking. Just make sure your character's body language is talking loud and clear.

CHeeR!

Shhhh!

Tiny text in a big bubble denotes muted speech.

HEY! I WOULDN'T DO THAT IF I WERE YOU.

Average-size text relates to a regular speaking volume.

HEY! I WOULDN'T DO THAT IF I WERE YOU.

HEY! I WOULDN'T DO THAT IF I WERE YOU.

Enlarge the text slightly for a raised voice.

Turn speech into a whisper by drawing your bubble with a series of dashes. The opaque effect shows the speech is inaudible to the other characters in the scene.

There are many graphical devices that you can use to give your characters different speech patterns. Most importantly, the volume of the speaker is indicated by the size of the text relative to its bubble. Text that can be clearly read and that fits easily into a bubble with white space around it, symbolizes a regular volume, while larger or smaller text can be used to show anything from hush to hullabaloo.

HEY! I WOULDN'T DO THAT IF I WERE YOU.

Take it to the max, and your character is shouting.

SEE ALSO Need further treatment? See Tutorial 18: Using Cartoon Devices, Page 66

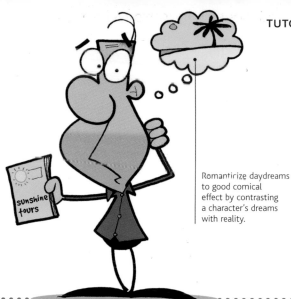

Romanticize daydreams to good comical effect by contrasting a character's dreams with reality.

THOUGHT BUBBLE

Dreamy, wistful, and cloud-shaped—the thought bubble is an ideal shape to house a character's private thoughts. Because the thoughts reveal your character's mood and personality, try to make your character's expression and body language consistent with his thoughts. Consider how your character will look while he is thinking.

"SPIKY" SPEECH BUBBLE

This exclamatory bubble is generally reserved for dramatic moments. It shows that the speaking character has delivered his line in an emphatic and powerful way, usually in a raised voice. It is also used to show sound coming from an electrical speaker, such as a radio.

Sharp angles on a bubble give the text a startling, mechanical feel. Increase the angles further for greater impact or a heightened sense of static interference.

Extend your character's personality with an individually-themed bubble.

Gee, Mom... do I <u>have</u> to go to school today?

The relaxed lines of this bubble and the addition of the musical notes convey a cheerful mood.

Stylized text can add to your graphical theme.

BRRRR! IT'S FUH-FUH FREEZING!

SUFFERIN' SUCCOTASH! THE CAGE DOOR'S OPEN AGAIN!!

HAPPY BIRTHDAY TO YOU – HAPPY BIRTHDAY TO YOU!

MEANWHILE... BACK DOWN ON THE SURFACE OF CYBERPLANET –

Give your bubble and its text a uniform look for maximum impact.

Illustrating key words is an excellent way to express atmosphere.

Text can be so much more interesting when it's enhanced with some graphical modifications. Themed text is not only exciting to the eye, but it communicates your message in a highly effective way.

STAY BACK, CAPTAIN- I'M ABOUT TO BLOW MY CIRCUITS!

Use colors in your bubble to enhance the mood.

"Clinic 6: Injecting Humor

SEE ALSO
Need further treatment?
See Tutorial 5: Getting Inspired, page 22

Doctor, Doctor, my characters don't raise a laugh! What can I do?

THE DOCTOR WRITES:

"There is no such thing as a comedy failsafe. A joke that makes one person fall apart laughing may not even raise a smile with another, and due to the broad appeal of cartoons it is fair to say that, apart from their effectiveness and flexibility as a medium to present jokes, there's no tangible source of humor in cartooning. Our only hope is to go with our gut feeling about what is funny and hope that someone else agrees. However, to make sure our humor is understood, it is important to create a cartoon character that is a good channel for our jokes. The following tips should put you on the right track."

SYMPTOMS
- Unfunny folks
- Grave gags
- Stale scenes

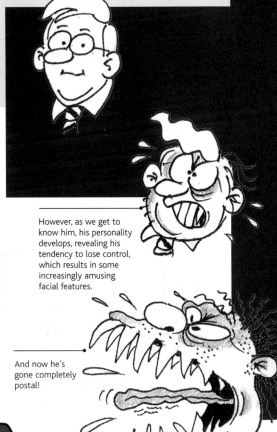

However, as we get to know him, his personality develops, revealing his tendency to lose control, which results in some increasingly amusing facial features.

And now he's gone completely postal!

CHARACTER DEVELOPMENT

You can develop a character all at once by hitting on the right facial expression, stance, clothes, or accessories, or you can develop a complex personality over a series of drafts. In order to make your audience laugh at your characters, they need to feel they know them. Misfortune is always funnier when it happens to someone you know. Try to utilize subtle nuances (such as accessories and expressions) to tell your audience as much as you can about your character, so that when something happens to him or her it will seem funnier.

One look at this character tells us he is smug and self-satisfied. His expression, body language, and clothing says it all. Now that we know that much about him, any gags we play on him will seem that much funnier. A joke works when the audience can relate to the character—the only way they will be able to do that is if you supply all the necessary information in advance.

CHOOSE YOUR SUBJECT

Certain subjects have always lent themselves to cartooning—politics, class differences, and social hierarchies of all kinds, sexual manners, new inventions, public events. Cartoon humor often works by prodding at a natural conservatism in the audience, but cartoons need to make fun of people in a way that enables them to share the joke, so that the shaft of wit is pointed but not too personally cruel.

Doctor's Notes

It isn't easy to predict what will make a successful visual joke. Sometimes off-the-wall humor starts as a minority preference, gets picked up as a cult, and eventually goes mainstream. Being funny is about following your instincts and being creative and spontaneous, so do not worry too much about obeying any rules. It is important for you to be able to develop your own style, which will happen naturally over time as you refine your technique and learn what works and what does not.

This cartoon appeared as the illustration to an article entitled "Caught in the housing trap?" and it wittily encapsulates the situation explored in the editorial. By presenting the dilemma plainly, without over-dramatizing the violent element, the artist shows sympathy with the victims while also raising a laugh.

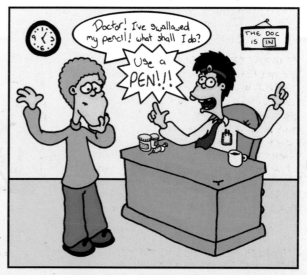

THE FORMAT OF A STANDARD CARTOON JOKE

▶ **Straight Man:** *This character sets up the joke by providing any information that is not already included within the frame which is necessary to make the punchline funny. The straight man or woman is not funny because often the joke is at his or her expense (which is always more effective if he carries himself with dignity), and because that provides a greater contrast of hilarity of the situation before and after the punchline.*

▶ **Funny Man:** *It is the funny man or woman's job to deliver the punchline in a comical way. A lot rests on the funny man's shoulders as his delivery of the line determines whether the joke works or not, which is why a few visual gags (silly expression, humorous accessories) often accentuate his appearance.*

▶ **Props:** *These help set up the joke by providing or reinforcing any information needed to set up the punchline (in this particular joke, the desk and doctor's instruments reinforce the impression that the cartoon is set in a doctor's consultation room).*

▶ **Labels:** *These are a straightforward form of props that offer vital information not made instantly clear by other props. They usually appear in the form of posters or signs.*

▶ **Feed Line:** *This line is the lead up to the punchline, and provides the last vital piece of information required to set up the whole situation, ready for the punchline to change it into something unexpected and (hopefully) funny. A feed line is not always necessary—jokes that have enough information provided by visual elements are known as "ham gags."*

▶ **Punchline:** *The funny bit; the line that reveals the joke.*

Next subject please!

TUTORIAL 20

Drawing Animals

Learning to draw animals is a daunting prospect, simply because they come in so many different shapes and sizes. However, as with drawing anything else, you can simplify the process by doing it in stages. Each stage offers an opportunity to refine your character until you are happy with it.

BASIC COMPONENTS

Here, a dog's body is broken down into modular parts. This exercise involves building a mental picture of the dog like a three-dimensional construction that can be viewed from any angle. Once the basic components are assembled, they can be combined and recombined to make a repertoire of active and expressive figures.

The front view presents the basic forms in cross-section: The bean-shaped torso becomes a circle.

In the three-quarters view, standing, the neck is hidden behind the head.

The turned body combines the front view (top) and the three-quarters view (right).

Unbalanced legs as the dog performs a leap.

Sitting: The hindquarters rest between the hind legs.

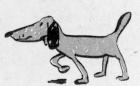

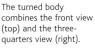

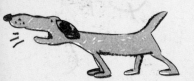

SIMPLIFICATION

If you have trouble drawing an animal face, sketch a simple face and draw the animal's most dominant feature around it, such as a lion's mane or a cat's whiskers.

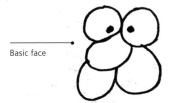

Basic face

Rooster

SEE ALSO
Need further treatment?
See Tutorial 14: Building Cartoon Heads and Faces, page 55

EXPRESSIONS

When animals are used as the main subject in a cartoon, they are more likely to be anthropomorphized: Four-legged creatures are made to stand up on their hind legs, and use their forelegs and paws like human arms and hands, while their faces have humanized expressions of pleasure, terror, rage, or craftiness.

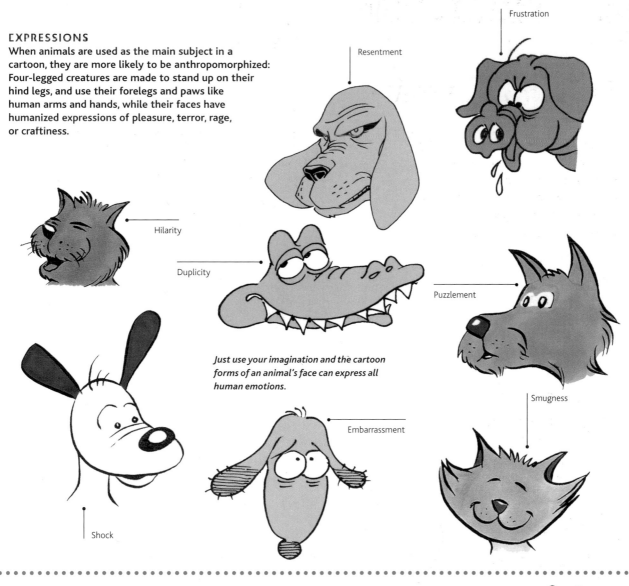

Resentment

Frustration

Hilarity

Duplicity

Puzzlement

Smugness

Just use your imagination and the cartoon forms of an animal's face can express all human emotions.

Embarrassment

Shock

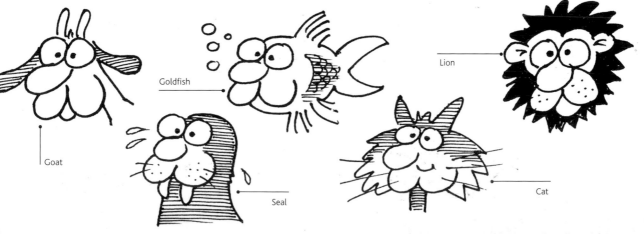

Goat

Goldfish

Lion

Seal

Cat

" Clinic 7: Unanimated Animals

SEE ALSO

Need further treatment?
See Tutorial 15: Capturing Expression, page 56

Doctor, Doctor! My animals look docile, depressed, and dull! How do I make them look animated, expressive, and really wild?"

SYMPTOMS

- Lifeless llamas
- Expressionless elephants
- Uncharismatic crocs
- Boring badgers

THE DOCTOR WRITES:

"Animals always seem more emotive when we can imagine what they are feeling, and the best way to do this is to make their expressions as human as possible. The practice of attributing human motivation, characteristics, or behavior to animals is known as anthropomorphism, and it is undoubtedly the best way to give your animal characters piles of personality."

STANCE

One very effective trick is to make your animal stand like a human, with hands and feet instead of paws or hooves. Now your animal can take on a whole world of human activities.

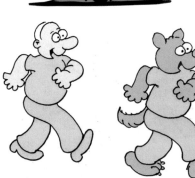

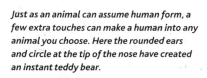

Just as an animal can assume human form, a few extra touches can make a human into any animal you choose. Here the rounded ears and circle at the tip of the nose have created an instant teddy bear.

Consider how you might portray the running man as an animal, perhaps by changing the feet to paws.

Use the dominant characteristics of the animal you want to portray, in this case the long snout and thick, fleshy tail of the alligator.

The mismatched eyes tell us everything we need to know about this character.

EYES

The eyes and brow of a face play an important part in any expression, which is why we look at people's eyes when they are talking to us. By drawing the eyes and brow large and clear, we can portray an enormous range of human expressions without touching the mouth and nose.

If you want an animal to look cute, make its eyes disproportionately large, and have the pupils looking slightly upward.

Eyes can be stylized and still be expressive.

Extremely feminine eyes give this hog a cool, comic twist.

Bowling puts the cartoon dog in postures impossible for a real dog.

ACCESSORIES

A well-placed accessory, such as a pair of glasses, gloves, or shoes, can give your animal a humorous novel twist.

Doctor's Notes

✛ Nonhuman characteristics endear us to animals, so do not leave these by the wayside. The trick with creating an animal character that works is getting the balance between human and animal qualities just right. A dog that acts like a dog has little comic potential, but one that walks and talks like a human keeps the audience guessing—what the doglike action will trigger the humor?

A change of heads from human to animal, while retaining the human occupations and accessories that go with them, gives this line-up of characters huge comic potential.

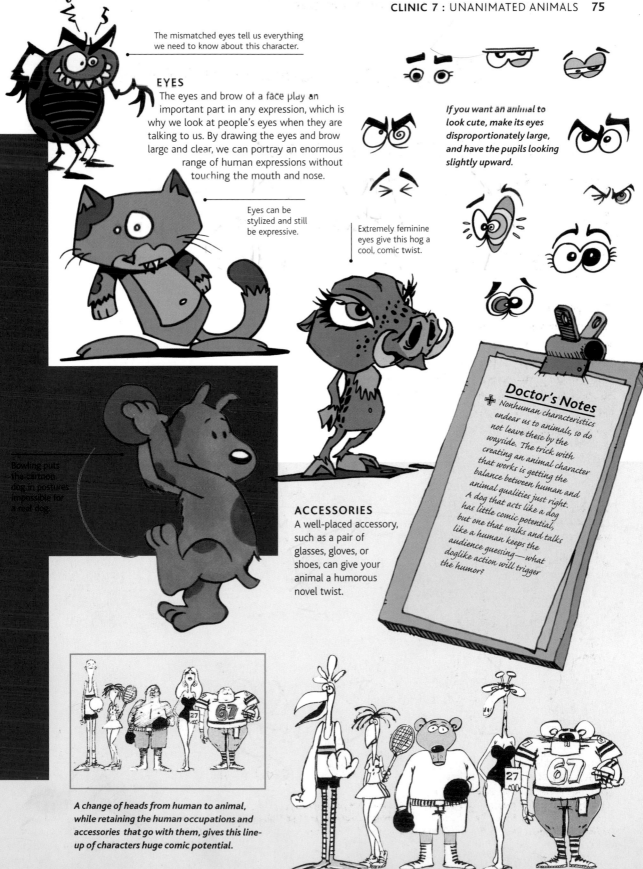

Next subject please!

TUTORIAL 21

Figures in Motion

Being able to draw smooth, well-proportioned figures is an essential skill for any budding cartoonist, but it is only half the challenge. If you cannot make your characters leap about animatedly and pose dynamically, they are in danger of looking repetitive and boring. Remember, your readers want something sensational, animated, and stimulating, so don't give them lifeless and dreary.

THE LINE OF ACTION

A drawing device known as "the line of action" is very useful in determining movement in your characters. The alligator on the left appears to be moving, but the line of action that passes through its body is vertical; this makes it look as though it is either skipping or jumping upward. Then, look at the alligator on the right. Here, the line of action is diagonal, which gives the impression that the character is moving forward. Tilt the line of action further for a more intense feeling of speed. The overall shape or form of a character also affects the action. Sometimes it is helpful to imagine the character as simply a shape rather than as a detailed figure. It is then easier to design action and movement poses successfully by stretching, squeezing, squashing, or bending the forms. Details can be added later.

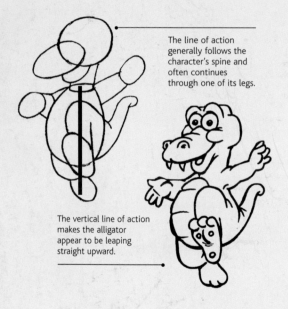

The line of action generally follows the character's spine and often continues through one of its legs.

The vertical line of action makes the alligator appear to be leaping straight upward.

First establish the line of action, then build the figure around it.

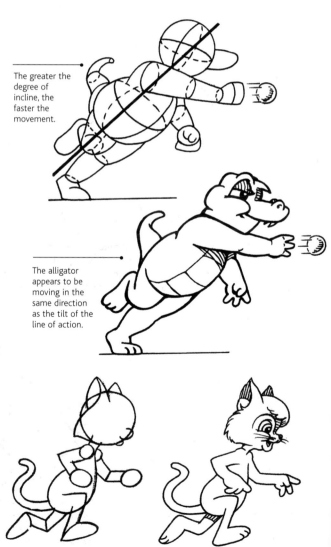

The greater the degree of incline, the faster the movement.

The alligator appears to be moving in the same direction as the tilt of the line of action.

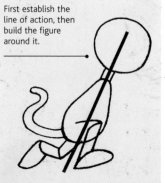

SEE ALSO
Need further treatment? See Tutorial 10: Easy Figure Construction Methods, page 47

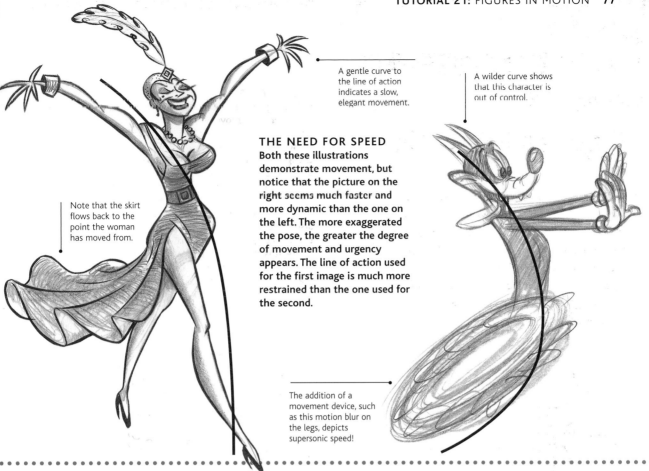

A gentle curve to the line of action indicates a slow, elegant movement.

A wilder curve shows that this character is out of control.

THE NEED FOR SPEED
Both these illustrations demonstrate movement, but notice that the picture on the right seems much faster and more dynamic than the one on the left. The more exaggerated the pose, the greater the degree of movement and urgency appears. The line of action used for the first image is much more restrained than the one used for the second.

Note that the skirt flows back to the point the woman has moved from.

The addition of a movement device, such as this motion blur on the legs, depicts supersonic speed!

SECONDARY MOTION
Another way to give your character movement is to use secondary motion. This involves using a character's extremities and appendages (hair, clothes, and accessories) to suggest movement in the body. For instance, if a character is moving forward fast, their hair and clothes will billow behind them. Therefore, if you draw your character with their hair and clothes flowing behind them, you will instantly create the impression that your character is moving. This basic principle can be translated into numerous different situations to create a strong sense of movement.

When the head is at rest, the only force affecting the hair is gravity, so the hair hangs down.

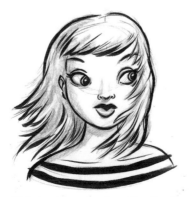

If the head moves in a linear direction, the hair will billow in its wake. The movement of the hair in the illustration above tells us that the head is moving from left to right.

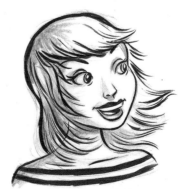

As the head turns more fully and quickly toward the right, the hair follows in the same direction. Centripetal force flings it out and away from the head.

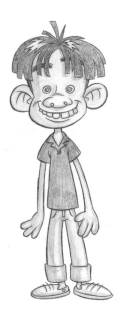

PEPPING UP PRESENCE

To liven up your figures and make them look more natural and energetic, you need to think about the physics of how the human form moves, and then put your own cartoon spin on it. Look at this character and the way he runs. How has movement been expressed?

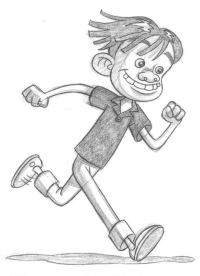

This exaggerated, forward-leaning pose, coupled with the billowing hair, shows us the character is moving fast.

ADDING WEIGHT

Make your character look more realistic by adding weight to their movement. In real life, when a person or animal moves, the weight of the different parts of their body affects the style of their motion—a 250 lb. (113 kg) man will not run in the same way as someone who weighs 112 lb. (51 kg). If you can show the effect of weight on your characters' movements, they will be more believable to your readers.

The lean man appears dexterous and flexible.

He can reach the floor with ease.

The fat man's extra volume inhibits his movement.

Touching the floor is physically impossible.

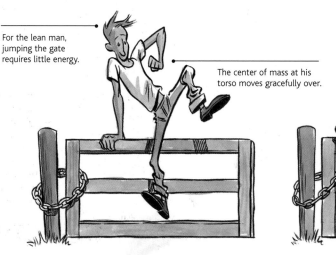

For the lean man, jumping the gate requires little energy.

The center of mass at his torso moves gracefully over.

For the fat man, scaling the same gate is quite a task.

His center of mass moves slowly, hugging the top of the gate.

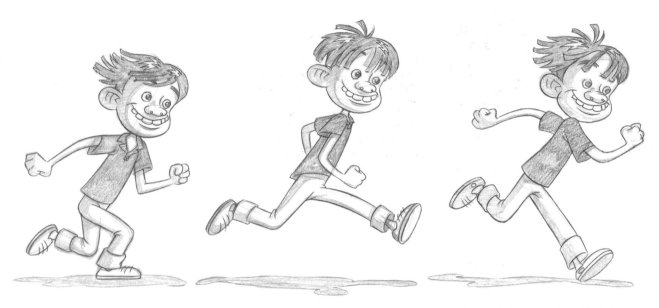

The force of the landing has pushed the center of mass and all extremities down.

This nimble leap is indicated by the significant distance between the boy and his shadow.

Notice how the limbs are energetically flung out, creating an impression of great enthusiasm.

MOVEMENT DEVICES

The simplest way to represent movement in a cartoon character involves using a few dashes, lines, or symbols to indicate where a character is moving. These are known as speed lines or energy lines, and can be used in a number of ways to show a character moving fast or slow, wobbling, or impacting with something else.

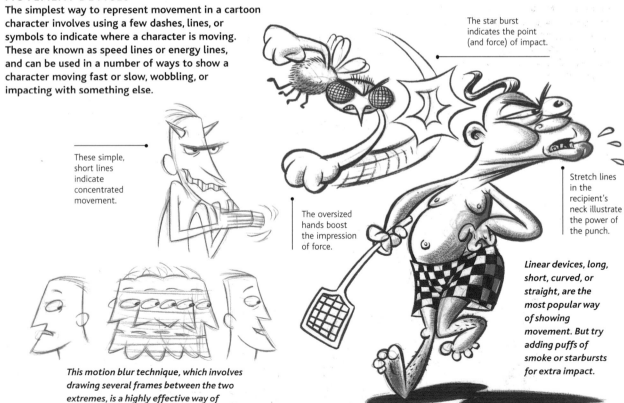

The star burst indicates the point (and force) of impact.

These simple, short lines indicate concentrated movement.

The oversized hands boost the impression of force.

Stretch lines in the recipient's neck illustrate the power of the punch.

Linear devices, long, short, curved, or straight, are the most popular way of showing movement. But try adding puffs of smoke or starbursts for extra impact.

This motion blur technique, which involves drawing several frames between the two extremes, is a highly effective way of illustrating swift movement.

Next subject please!

TUTORIAL 22

Exaggerating Action

SEE ALSO
Need further treatment?
See Tutorial 21: Figures in Motion, page 76

Cartoonists often take the means of expressing movement in a drawing to extremes. Exaggerating action has great potential for humor, not to mention a heightened sense of drama. Create a truly striking image by starting with a lively line of action. Add plenty of movement devices (see page 79) and make sure your pose is impossible to achieve in real life!

TAKE IT TO EXTREMES

Look at the series of illustrations below—notice that the cartoon figures on the right appear in poses that the life-drawn figures on the left could never produce. Cartoonists never do things by halves and the extreme movements made by the cartoon figures are the most striking, with immediate humorous effect.

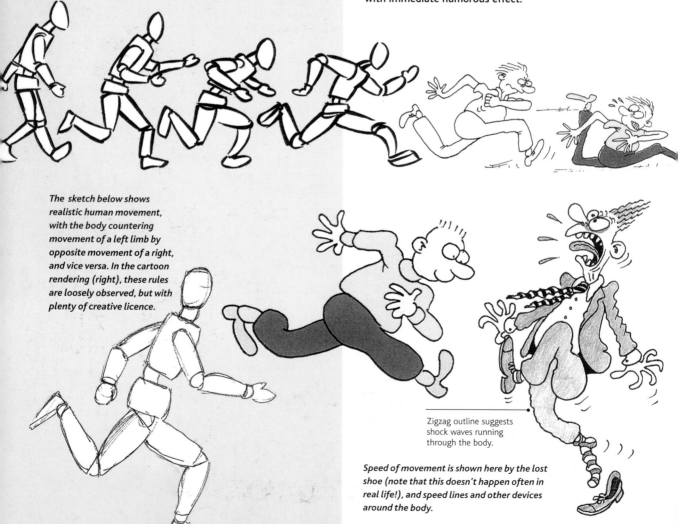

The sketch below shows realistic human movement, with the body countering movement of a left limb by opposite movement of a right, and vice versa. In the cartoon rendering (right), these rules are loosely observed, but with plenty of creative licence.

Zigzag outline suggests shock waves running through the body.

Speed of movement is shown here by the lost shoe (note that this doesn't happen often in real life!), and speed lines and other devices around the body.

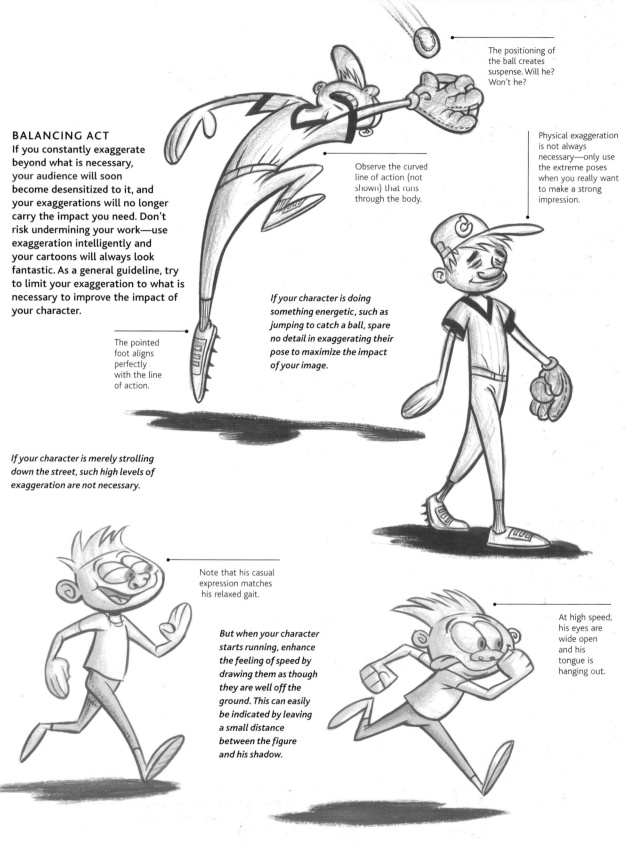

The positioning of the ball creates suspense. Will he? Won't he?

Physical exaggeration is not always necessary—only use the extreme poses when you really want to make a strong impression.

Observe the curved line of action (not shown) that runs through the body.

BALANCING ACT

If you constantly exaggerate beyond what is necessary, your audience will soon become desensitized to it, and your exaggerations will no longer carry the impact you need. Don't risk undermining your work—use exaggeration intelligently and your cartoons will always look fantastic. As a general guideline, try to limit your exaggeration to what is necessary to improve the impact of your character.

If your character is doing something energetic, such as jumping to catch a ball, spare no detail in exaggerating their pose to maximize the impact of your image.

The pointed foot aligns perfectly with the line of action.

If your character is merely strolling down the street, such high levels of exaggeration are not necessary.

Note that his casual expression matches his relaxed gait.

But when your character starts running, enhance the feeling of speed by drawing them as though they are well off the ground. This can easily be indicated by leaving a small distance between the figure and his shadow.

At high speed, his eyes are wide open and his tongue is hanging out.

Clinic 8: Beating Tight Deadlines

"Doctor, Doctor! Building up a character is time-consuming. I need a quick fix!"

THE DOCTOR WRITES:

"Few comic artists can pick up a pencil and instantly produce a cartoon masterpiece, and the ones that can have usually acquired their skill through an arduous schedule of practice, practice, and more practice. However, there may be times in your cartooning career when you are called upon to create something dazzling at a moment's notice. In these instances, it is always a good idea to keep a few tricks up your sleeve."

SYMPTOMS
- No time for stages
- Need to impress on the spot!

TRICK 1: THE OLD FAITHFUL

Most cartoonists have a couple of styles that they have used thousands of times, and can easily replicate in seconds. Because of the sheer number of times they have drawn in the same style, they can simply improvise the finished piece right away.

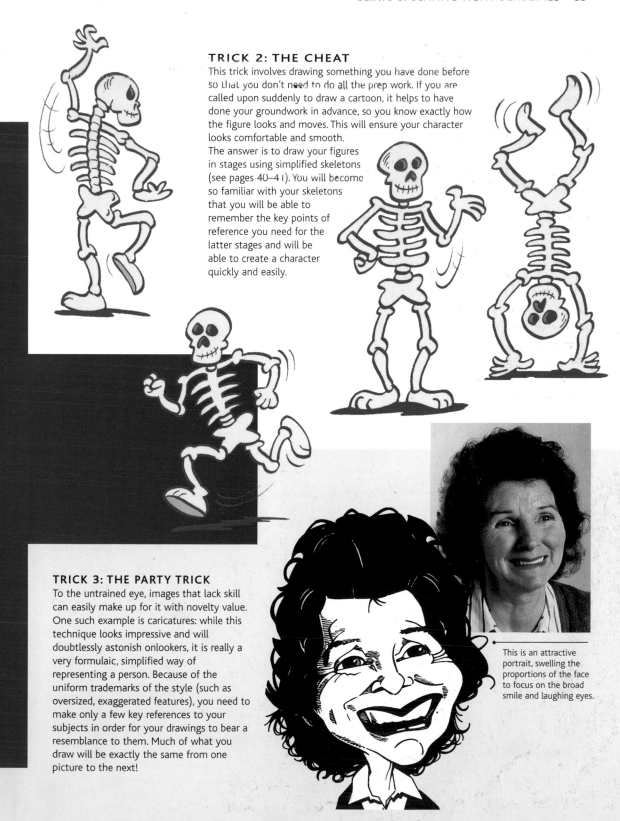

TRICK 2: THE CHEAT

This trick involves drawing something you have done before so that you don't need to do all the prep work. If you are called upon suddenly to draw a cartoon, it helps to have done your groundwork in advance, so you know exactly how the figure looks and moves. This will ensure your character looks comfortable and smooth.

The answer is to draw your figures in stages using simplified skeletons (see pages 40–41). You will become so familiar with your skeletons that you will be able to remember the key points of reference you need for the latter stages and will be able to create a character quickly and easily.

This is an attractive portrait, swelling the proportions of the face to focus on the broad smile and laughing eyes.

TRICK 3: THE PARTY TRICK

To the untrained eye, images that lack skill can easily make up for it with novelty value. One such example is caricatures: while this technique looks impressive and will doubtlessly astonish onlookers, it is really a very formulaic, simplified way of representing a person. Because of the uniform trademarks of the style (such as oversized, exaggerated features), you need to make only a few key references to your subjects in order for your drawings to bear a resemblance to them. Much of what you draw will be exactly the same from one picture to the next!

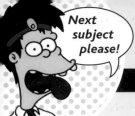

Next subject please!

TUTORIAL 23

Bringing It All Together

A fully convincing character will communicate the same message in every aspect of its construction. A character whose expression is at odds with its pose and outfit will cause confusion for the reader. Consistency is essential—even down to the tiniest of details such as the hue of each item of clothing.

The examples on these pages bring together everything you have learned in this chapter about figure construction, body language, expression, clothing, hair, and accessories. They also introduce you to the possibilities for character development suggested by color which is examined in detail in the next chapter.

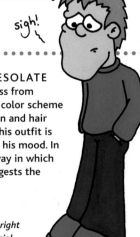

JAUNTY AND JOVIAL
The excitement and buoyancy of the character (at right) is clearly obvious. The reason this impression is so strong is that every aspect of the character echoes the same positive, happy message. The pose and expression are unmistakably ecstatic; the colors are bright and bubbly; and the style and speech are unquestionably joyful.

Plenty of references ensure an easily recognizable character. This French chef is identified by his apron, tall hat, and curly moustache. His wide girth and big smile suggest he is happy in his work.

His upright pose indicates his confidence in the kitchen.

Gray hair and skin tones demonstrate a lack of liveliness.

SEE ALSO
Need further treatment?
See Tutorial 8:
What Makes a Cartoon Character?,
page 34

The facial expression, with its open mouth and raised eyebrows, confirms this character's sense of shock.

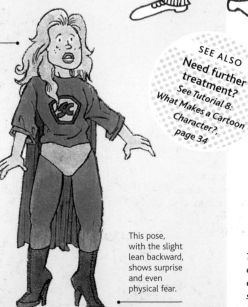

This pose, with the slight lean backward, shows surprise and even physical fear.

sigh!

DESPONDENT AND DESOLATE
This poor chap oozes sadness from every pore. Notice how the color scheme suggests depression. His skin and hair are drab and colorless, and his outfit is symbolically blue to reflect his mood. In addition, the understated way in which his speech is presented suggests the overall feeling of gloom.

This female superhero (left) has all the right clothing, but her body language and facial expression tell us that everything is not as it seems. Is she really as "super" as she wants us to believe?

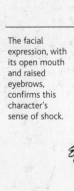

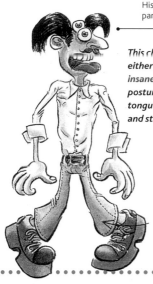

His misplaced eyes are particularly bizarre.

This character appears either ill or completely insane with his peculiar posture, enlarged tongue, rolling eyes, and strange hairstyle.

Hair standing up in spikes and the red skin tone shows he is barely able to control his anger.

FURIOUS AND FUMING

There is no mistaking how this fellow feels—utterly hopping mad! The angular, spiky drawing style helps to create a feeling of tension, and the red color scheme heightens the impression of rage we get from the facial expression and pose. The clouds of steam rapidly escaping from the ears provide a comic touch that adds to the theme.

ROUGH AND RUGGED

This person's gruff demeanor is produced by a composite of factors. His frowning eyes, gritted teeth, and clench-fisted, menacing pose give him an unfriendly, intimidating air. His shaven head and designer stubble, coupled with the dark leather jacket, jeans, and boots show that he styles himself for rough-and-ready durability—an impression confirmed by the wrench accessory.

The snazzy suit suggests his Italian connections.

The gangster cliché is perfectly illustrated here. His clothing and accessories (dark glasses, the cigar), and his menacing stance make him very convincing...

The classic gangster violin case.

What hides behind this tough-guy visage?

STRANGE AND SURPRISING

The crouched pose, flailing tail, pointed ears, and wild hair of this creature give it an untamed, freakish appearance. Because these characteristics are combined with a bipedal form and humanoid facial features, it appears simultaneously both alien and familiar.

Give an alien some humanoid features to give it anthropomorphic appeal.

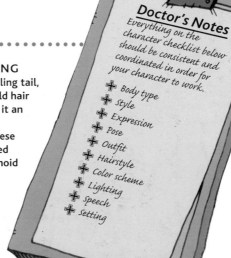

Doctor's Notes

Everything on the character checklist below should be consistent and coordinated in order for your character to work.

✚ Body type
✚ Style
✚ Expression
✚ Pose
✚ Outfit
✚ Hairstyle
✚ Color scheme
✚ Lighting
✚ Speech
✚ Setting

" Clinic 9: Using Clichés in an Emergency

Doctor, Doctor! I've backed myself into a corner with my story—

my creative juices have run dry and I'm desperately in need of a way to pep up my cartoon creation and get him back on his saga's path!"

THE DOCTOR WRITES:

"This is a very unorthodox treatment for such a problem, and I wouldn't normally recommend it, but if you are absolutely stuck for ideas, your creative juices have completely and absolutely dried up, and all other attempts at remedying the problem have failed, you might consider using... the cliché! Clichés are ideas that have lost their initial impact and strength because of overuse, although that is not to say they don't have their place. Applied in a tongue-in-cheek fashion, or with an original spin, a cliché can be an extremely useful device for helping us out of a tight spot."

SYMPTOMS
- Gridlocked plot
- Short on ideas
- Need a quick fix

WHEN TO USE A CLICHÉ

There are two main reasons to use a cliché. The first arises when you can think of a humorous way to work a cliché into your story. These instances can have comical results, but don't be tempted to use clichés in this fashion too frequently because they soon lose their comic appeal. The second reason you might use a cliché is when you can't think of any other way to get your story moving.

HOW TO USE A CLICHÉ

Clichés are generally considered a dim-witted storytelling device, so you should only ever use them in a tongue-in-cheek fashion. Even if you really can't think of any other way to push your story forward, you should always use your cliché in an ironic sense— you need to present yourself as being above using a cliché in its regular format for the sake of your credibility!

SEE ALSO
Need further treatment?
See Clinic 3:
Unblocking the Block,
page 30

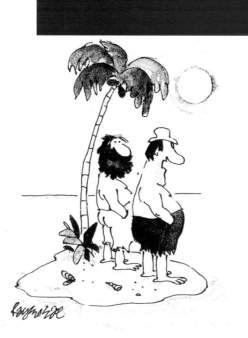

"If you must know—I won a world cruise in this cartoon captions competition."

This desert island cliché works beautifully as it pokes fun at itself and the entire genre.

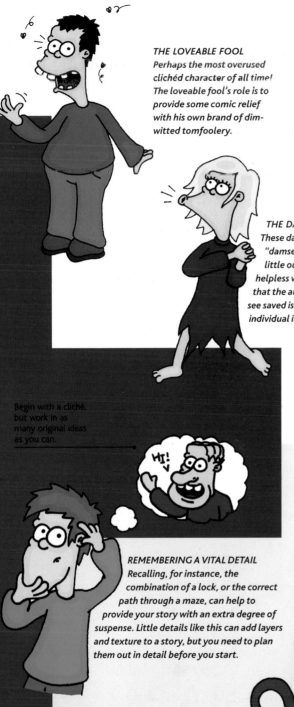

THE LOVEABLE FOOL
Perhaps the most overused clichéd character of all time! The loveable fool's role is to provide some comic relief with his own brand of dim-witted tomfoolery.

CHARACTER CLICHÉS

In situations of dire emergency, the introduction of a clichéd character that is at once recognizable can help to jump-start a troubled tale. Because everyone knows what to expect from these characters, it is easy to come up with ideas on how they can interact with the story and get it moving again. Try to be as original as you can even when using a clichéd character—you will lose the attention of your audience if they think they have seen it all before.

Cool sunglasses, the catapult... you can play on the cliché concept by adding lots of stereotypical accessories.

THE DAMSEL IN DISTRESS
These days the idea of the "damsel" is becoming a little outdated, but a helpless victim character that the audience will want to see saved is an important individual in any hero saga.

THE SMART ALECK KID
Wisecracking, troublemaking, and cool as a cucumber. The smart aleck's role is also for some comic relief, although this time it is delivered through his sharp, deadpan one-liners.

Begin with a cliché, but work in as many original ideas as you can.

HI!

STORYTELLING CLICHÉS

It is a cop-out to use a cliché in a plot unless you can introduce it in a totally innovative and original way. It can be avoided by planning your story before you start. Remember, freshness and imagination are the keystones of successful cartooning, so don't repeat or copy an idea, even when using clichés.

REMEMBERING A VITAL DETAIL
Recalling, for instance, the combination of a lock, or the correct path through a maze, can help to provide your story with an extra degree of suspense. Little details like this can add layers and texture to a story, but you need to plan them out in detail before you start.

HEY! I DIDN'T KNOW I COULD DO THIS!

DISCOVERING AN UNKNOWN TALENT
This cliché is perfect for getting a hero out of a tight spot. However, it won't seem credible if you surprise your audience with it, so you need to make sure it is hinted at several times prior to it actually happening.

WAKING FROM A DREAM
If ever there was a cop-out storytelling device, this is it! However, you can just about get away with it if it is an integral part of a sophisticated plot line or funny joke.

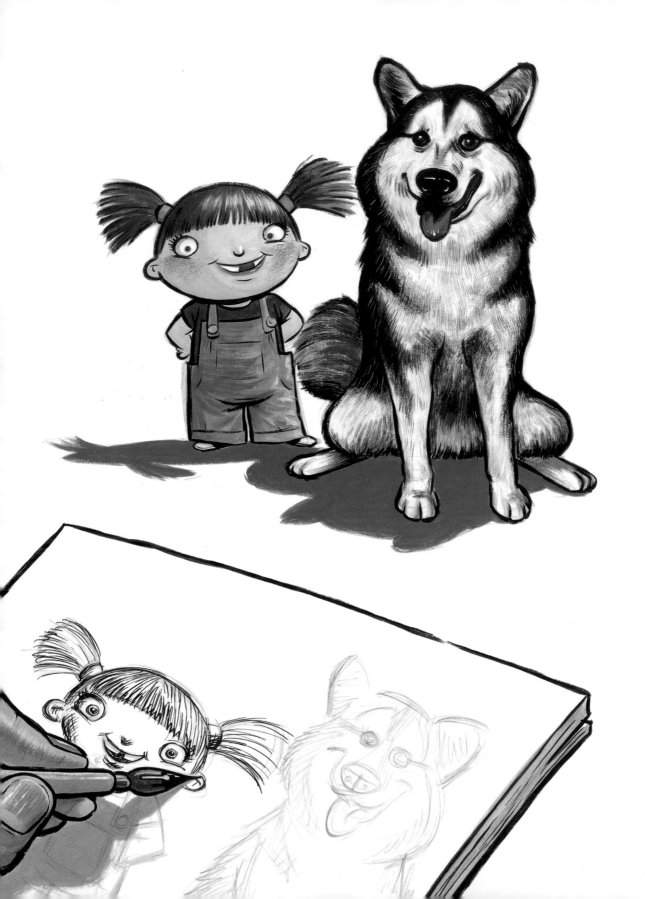

Inking and Coloring Techniques

In the previous chapters, we have established how to draw cartoon characters, and how to make them move and pose dynamically. ✠ Now it is time to bring them to life with color. This is the final stage on the road to creating a fully rendered character, and is consequently the most exciting. ✠ It is a perfect opportunity for you to let loose the designer in you and come up with some dazzling color ideas.

TUTORIAL 24

Shading

Most forms of illustration use gradients of shade to create the illusion of three dimensions, but the cartoon medium generally favors bold blocks of color and shade, known as cell shading. Shading for cartoons can seem difficult at first, but with the right knowledge and tools, adding shading and shadows is simple. Before you begin, think about what you want to achieve and whether you need to shade at all. Are you using shade to give form to a figure, or to add atmosphere to your setting?

SHADING TOOLS

You will find that using a pen to add shade and shadows is much easier than using a brush. A pen is neater and will give a cleaner appearance. However, try experimenting with both pens and brushes as they have different benefits and limitations.

Dip pens, despite being difficult to learn to use, are an excellent shading tool. Nibs come in different sizes, so start with a medium-size nib and figure out what works best for you (see page 15).

While a brush gives you much less control than a pen, you may appreciate its fluid movement. Your shading brush needs to be of a good quality because you will be using it for intricate work. Sable brushes are expensive but responsive, and are available in many sizes from very fine to large.

SEE ALSO
Need further treatment?
See Clinic 10:
Hatching,
page 96

Choose a brush that is flexible and maintains a clean point.

Don't leave brushes bristle-end down in a jar—the hairs will splay out.

HOW TO SHADE

This illustration demonstrates the use of shading and shadows to define volume and give solidity to a drawing. Shading requires concentration and can be exasperating, so make sure you are comfortable before you start. Sometimes the ink or paint can harden on your brush or pen, so keep a jar of water handy to rinse your tools in. When shading, do not worry about making the occasional mistake—ink and paint are permanent, but you can cover errors with opaque white paint.

This "before" image works perfectly well as a cartoon, but the shaded image (indicated with an arrow below) shows the difference that shading and shadows can make. Suddenly the figure has volume and the mood is enhanced.

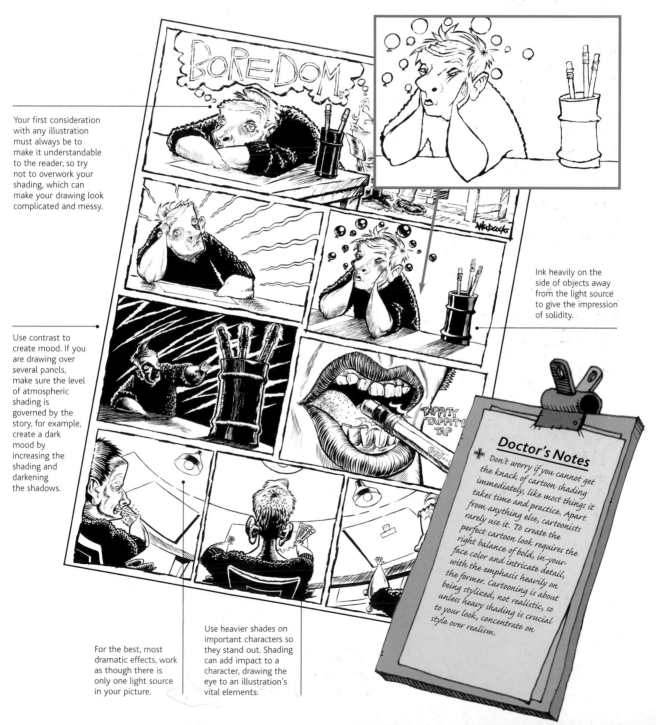

Your first consideration with any illustration must always be to make it understandable to the reader, so try not to overwork your shading, which can make your drawing look complicated and messy.

Ink heavily on the side of objects away from the light source to give the impression of solidity.

Use contrast to create mood. If you are drawing over several panels, make sure the level of atmospheric shading is governed by the story, for example, create a dark mood by increasing the shading and darkening the shadows.

Doctor's Notes

Don't worry if you cannot get the knack of cartoon shading immediately, like most things it takes time and practice. Apart from anything else, cartoonists rarely use it. To create the perfect cartoon look, requires the right balance of bold, in-your-face color and intricate detail, with the emphasis heavily on the former. Cartooning is about being stylized, not realistic, so unless heavy shading is crucial to your look, concentrate on style over realism.

For the best, most dramatic effects, work as though there is only one light source in your picture.

Use heavier shades on important characters so they stand out. Shading can add impact to a character, drawing the eye to an illustration's vital elements.

Next subject please!

TUTORIAL 25

Choosing Colors

Color is at the heart of cartooning. Bright, bold schemes are what we love about cartoons, and their style and flamboyancy make them appeal to a wide and varied audience. However, choosing color is not just about making your image eye-catching. Color also has symbolic properties that you can use to communicate information to your audience.

When choosing cartoon colors, forget wishy-washy pastels—choose colors that are bright and highly saturated (contain lots of pigment) if you want your cartoon to turn heads.

SEE ALSO
Need further treatment?
See Tutorial 28:
Lighting,
page 104

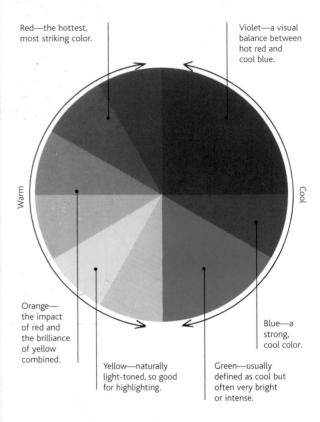

Red—the hottest, most striking color.

Violet—a visual balance between hot red and cool blue.

Warm

Cool

Orange—the impact of red and the brilliance of yellow combined.

Yellow—naturally light-toned, so good for highlighting.

Green—usually defined as cool but often very bright or intense.

Blue—a strong, cool color.

CHOOSING COLORS

Some colors go better together than others do. A color wheel can help you choose shades that complement each other and find color schemes that are pleasing to the eye. Opposite colors on the wheel are known as "complementary," while colors next to each other make for harmonious relationships. Use the color wheel above to discover combinations that work for you.

TONE AND HUE

A hue is a shade of a pure color (the exact color of a pigment), while a tone is the intensity of a hue (the saturation of that pigment). Changes in tone and hue work well together in color schemes, and you only need to use one color of paint in different concentrations.

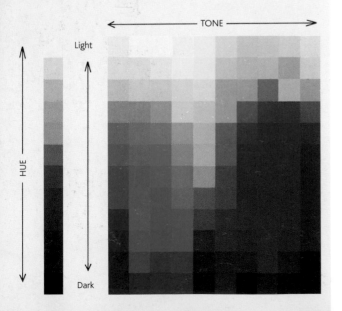

← TONE →

Light

HUE

Dark

The color chart (left) shows exactly what we mean by tone and hue. The tone, which relates to the horizontal axis of the chart, changes color as you move from left to right. The hue, which relates to the vertical axis, changes the saturation of each color as you move up and down.

COLOR TEMPERATURE

Colors can be grouped into two categories—warm colors, such as yellow, orange, and red, and cold colors such as blue and green. These colors are useful for creating atmosphere in a scene, and they work well when grouped together in schemes.

Blue and white will give your illustration a frosty feel.

These pictures illustrate how selective color schemes create atmosphere in backdrops. Experiment with different colors, tones, and hues to fine-tune a color scheme to give just the right mood.

Reds, oranges, and yellows indicate heat and intense sunlight.

Earthy colors, such as greens, browns, and blues, offer a relaxing ambience.

SYMBOLIC COLORS

Some colors are used to symbolize mood and emotion. You will be familiar with the terms "green with envy," "seeing red," and "feeling blue." These colors are synonymous with emotions, and you can use them in cartoons to tell the reader about your character's mood or to add atmosphere to a scene.

Green is synonymous both with envy and with illness.

A blue skin tint tells us that the character is depressed.

A red face signifies rage, although a red outfit (or rose) can symbolize passion.

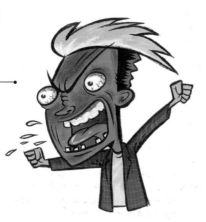

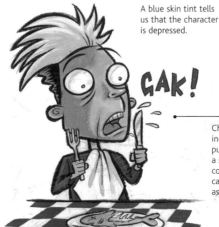

Choking is often indicated by a purple face. Using a surprising facial color, such as purple, can also convey astonishment.

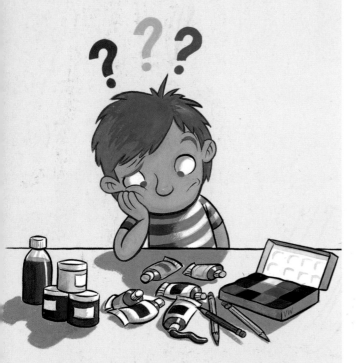

Next subject please!

TUTORIAL 26

Applying Color

Getting your cartoon colors right is essential because a great cartoon is defined by its look, which should be bright, loud, and in your face! Because of the contemporary, innovative nature of cartoons, it is important for them to look fresh and new, not drab and outmoded. The type of paint you choose and how you use it will affect the finished appearance of your cartoon. Here, we look at ways to help you achieve the bright, modern look you need.

SEE ALSO
Need further treatment?
See Tutorial 2:
Paints, Inks, and Other
Equipment,
page 14

MIXING PAINT

Gouaches and acrylics come in tubes, and will need to be mixed—both with each other and with water—to create the right shades for the job. The mixing process takes practice. If too much water is added, the paint will be thin and runny, but if there is not enough water in the mix, the paint will be lumpy and difficult to use. When you first start mixing, take it slowly, adding just a small amount of water and paint at a time. Soon you will become familiar with your paints and the mixing process will become second nature.

▸ *Always add dark colors to light when mixing—you will use less paint this way, and it is easier to get the exact shade you are looking for.*

▸ *Mix your paints on a nonporous surface, such as an old plate. This makes it easier to mix paint to the right consistency—thin enough to be easy to use, but also opaque enough to create bright, uniform fills.*

▸ *Mix more paint than you will need. This may seem wasteful, but if you run out of a color, it is difficult to recreate exactly the same shade.*

▸ *Make sure you mix paints thoroughly, otherwise your colors will be streaky.*

▸ *If you need to save a paint mixture for later, keep it in an airtight container or cover it in clingfilm so it does not dry out.*

▸ *For perfect skin tone, add a small amount of orange or brown to white.*

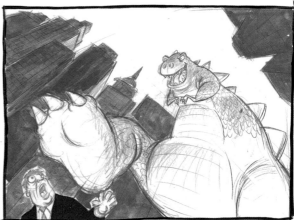

1 *Start by painting a tonal background. Simply fill in large empty spaces with uniform color. This will help you get your general color scheme in place, and it acts as a base onto which you can paint any additional detail you may require. Keep your brushstrokes going roughly in the same direction to achieve a uniform grain.*

PUTTING PAINT TO PAPER

Learning to paint is predominantly a process of trial and error. Some basic steps are outlined below—these will give you some starting points, but, as with sketching, you will need to practice in order to work out what works best for you.

2 Once the first layer of paint has dried thoroughly, it is time to add shadows and darker shades. Simply paint them directly over the top of the first coat. This way, you don't need to worry about making two areas of color meet neatly without one bleeding into the other.

INKING

Once your paint has completely dried, you may want to emphasize your outlines by going over them with a pen. Providing you have a steady hand, this is an easy process and will give your cartoon a really professional finish.

▶ *Start by simply tracing your pencil lines with a waterproof, colorfast marker to produce solid, dark lines that will stand out and clarify your image.*

▶ *Once you have mastered the steady hand required in using markers, try experimenting with dip pens. These take a lot more practice to become comfortable with, but give you the useful advantage of being able to vary the width of your lines.*

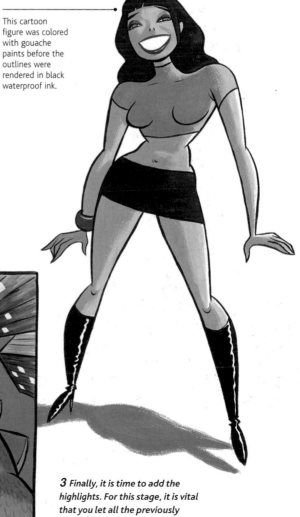

This cartoon figure was colored with gouache paints before the outlines were rendered in black waterproof ink.

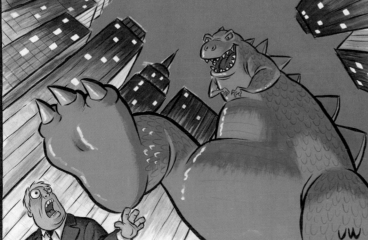

3 Finally, it is time to add the highlights. For this stage, it is vital that you let all the previously painted areas dry completely, because white paint is easily influenced by other colors.

Clinic 10: Hatching

Doctor, Doctor! My shades are shocking and my tones are terrible! How do I stop my shading from turning into a major mess?"

SYMPTOMS
- Flat figures
- Trite textures
- Bad lighting
- Lousy effects

THE DOCTOR WRITES:

"Cartoon shading is a delicate balance of boldness and detail. On the one hand, excessively detailed shading looks out of place in a cartoon, but not enough attention and accuracy in your shading can look ugly and messy. Hatching is a technique for creating simple yet effective tones without having to put your pen down!"

HATCHING

Hatching is simply a pattern of lines that represent shade. It can vary from a minimal amount of lines, to many lines crisscrossed to represent deep shade.

1 *Simple hatching is as basic as hatching gets—one set of parallel lines pointing in the direction of the light source gives an effective impression of shadow.*

2 *Crosshatching is where a second set of parallel lines is added perpendicular to the first, giving a denser fill for when you need fuller shadows.*

3 *If you need an even denser look, just keep adding more sets of lines until you are happy with your tone. This is known as multiple hatching.*

4 *Hatching can sometimes look a little crude. One way to improve the quality of your crosshatched tones and add mass and volume is to follow the contours of your object.*

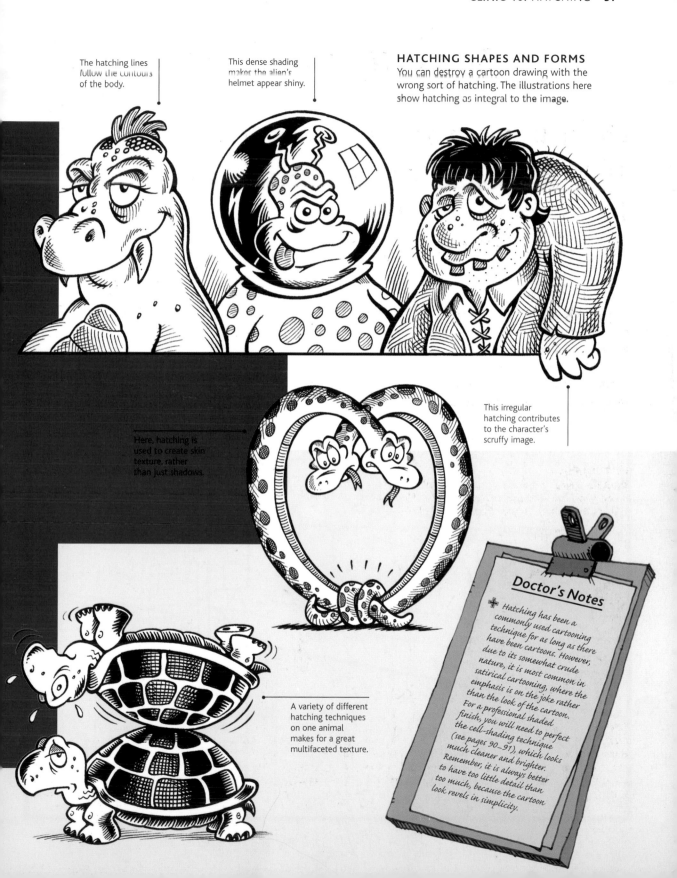

The hatching lines follow the contours of the body.

This dense shading makes the alien's helmet appear shiny.

HATCHING SHAPES AND FORMS
You can destroy a cartoon drawing with the wrong sort of hatching. The illustrations here show hatching as integral to the image.

This irregular hatching contributes to the character's scruffy image.

Here, hatching is used to create skin texture, rather than just shadows.

A variety of different hatching techniques on one animal makes for a great multifaceted texture.

Doctor's Notes
Hatching has been a commonly used cartooning technique for as long as there have been cartoons. However, due to its somewhat crude nature, it is most common in satirical cartooning, where the emphasis is on the joke rather than the look of the cartoon. For a professional shaded finish, you will need to perfect the cell-shading technique (see pages 90–91), which looks much cleaner and brighter. Remember, it is always better to have too little detail than too much, because the cartoon look revels in simplicity.

Composition and Layout

Successful composition and layout involves choosing elements
to go into your picture and putting them together in an
interesting and entertaining way that gets your message across
clearly. ✠ Ideally, a cartoon will have a focal point
(usually the main character of the story) that draws the eye,
while important elements should be grouped in a concentrated
explosion of activity. ✠ In this chapter, we look at
the essential elements of composition and layout that
can be used to create focal points: setting, lighting, viewpoint,
and how to arrange the action.

Next subject please!

TUTORIAL 27

Setting

The term "setting" refers to much more than the background in each scene. Often, the world we create for our characters to roam is what draws our readers into the story. An evocative setting should not only provide atmosphere and show the location of our characters, but also be intriguing and exciting in its own right. Done well, a great setting can be pure rocket fuel for a reader's sense of escapism.

SEE ALSO

Need further treatment?
See Tutorial 7: Exciting Writing, page 28

REFERENCE MATERIAL
Photographs are the most frequently used source of reference for cartoonists. Below are two principal ways of using them for background architecture.

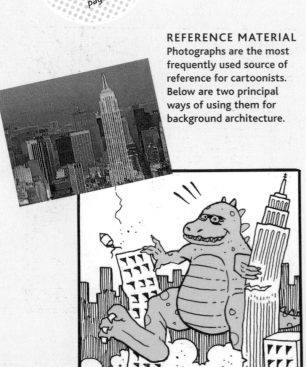

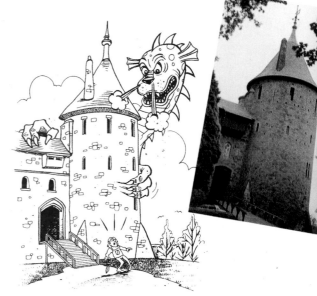

INFORMATION USED AS REFERENCE
A preconceived cartoon image takes minor incidental detail of the Empire State Building from the photograph of Manhattan's skyline.

PICTURE USED AS REFERENCE
The shape of the castle and the viewpoint of the photograph are transferred directly. There are minor changes, but the important difference is in how the cartoon image is rendered.

BUILDING A BACKGROUND

The purpose of a background is to show your reader when or where your characters are situated. Graphically, this means drawing the surfaces that surround a figure in order to convey all the information necessary for a gag. Treat the background as if it were built from the figure outward, gradually shaping it around your character. This is illustrated as a stage-by-stage process in this series of drawings.

Show that your horizontal ground is not empty. Make it an environment: break the horizon with a vertical line.

Ground the floating figure on a horizontal surface. A simple horizon line is enough.

Distinguish the environment—turn it into a location. Use pictorial details and props to define time and place as precisely, or as vaguely, as necessary.

Dramatize the drawing. Render areas of black or graduated tone to add weight, solidity, depth, or mood.

PERSPECTIVE

Perspective can be used to make objects appear larger or smaller. In the real world, the amount of perspective that affects an object is proportional to its size and its distance from your viewpoint. A large object, such as an elephant, will be strongly affected by perspective, while a small object, such as a mouse, will be comparatively unaffected.

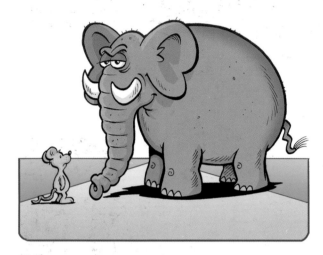

Look at the difference in the way perspective affects the elephant and mouse. Here, they are standing in almost the same place in relation to the horizon. The focus of the scene is on the former because of its size. Perspective plays a large role in the drawing of the elephant—note the vertical distance between its left and right feet—while the tiny mouse is virtually unaffected.

Reposition the characters and the scene changes completely. The emphasis is now heavily on the mouse because of the amount of space he takes up in the frame. His new size (relative to the frame) symbolizes how confident he feels—see how important such small factors are in determining an overall impression.

THE HORIZON LINE

The position of the imaginary line where the land and sky meet can tell us a lot about the scale of our scene, and it is good practice to roughly plot it during the early stages of construction. As a rule, the horizon falls roughly in line with your character's eyes if your character is standing on the ground. If you make the horizon lower, it will give your scene an expansive effect, while a high horizon will show less scenery and give an enclosed effect to a scene.

Normally we position the horizon line at the level of a character's eyes. It's an angle we're used to when looking at other people and it shows a clear amount of both land and sky, which helps us to set the scene.

Position your horizon line at the bottom of the frame and you'll have loads of room to fill the picture with scenery. Your character will be less affected by foreshortening, but look tall in comparison to the surroundings.

A horizon line at the top of the frame (or even above it), ensures that the focus is on the character rather than the scenery. Remember, you don't always need to SEE the horizon in order to plot your scene—just keep it in mind.

STIMULATING SETS

Aside from the technical details of horizon and perspective, a backdrop can impart important subtextural information to the reader. Once you have built up the background graphically, you need to consider what you want it to tell the reader about the characters you might place in it. Details of place and location also provide information on who the characters might be and what they might be doing. These pictures show the same figure against a series of different backgrounds.

The desert island scene is a comedy favorite in cartooning—the "sinking ship" prop verifies what we've already guessed about the situation. As always, the comic element of the scene lies in the reaction of the subject.

This simple set is the perfect platform for a few written gags. Show some of your character's unique expressions and suddenly it's the SITUATION that becomes funny.

This set is ideal for revealing your character's true colors—presented in the right way, a scared character can be hilarious. As there are no other characters in the scene, the emphasis will be on visual slapstick humor.

What the heck are we doing out here? Place your character in an unusual choice of location, and immediately your audience will be intrigued and asking themselves that same question.

Next subject please!

TUTORIAL 28

Lighting

Lighting is a great atmospheric tool for cartoonists and can be used to create scenes full of mood and tone. The intensity, color, and direction of light say a lot to us about a scene and its characters, and light can be an effective tool for reinforcing a theme. The atmospheric quality of lighting leads us to conclusions about events and people, and we can use it to guide our readers along a story's path.

When light comes from above, the head, brow, and nose are well lit, but the eyes and mouth are concealed by shade making it difficult for us to judge what our character is thinking. This gives them an ominous air. Notice how the general use of poor lighting gives the whole scene a shady, sinister ambience.

DIRECTIONAL LIGHT
When adding shadows and highlights to a figure, try and visualize it as a three-dimensional object. The parts of skin or clothing angled toward the light source will reflect the most light, while the areas angled away, or behind a ridge, will be in shadow. Use a torch and a mirror to determine where prominent areas of shadow will lie when your character's face is lit from different angles.

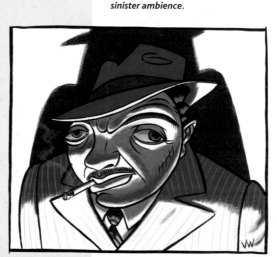

When lit from below, the face and head are concealed by shadow, but the important, expressive features (the eyes and mouth) are well illuminated. However, this type of lighting can be very unflattering and show unusual lines of shadow across the features, giving familiar faces a different slant. Perfect for an expressive character in strange circumstances!

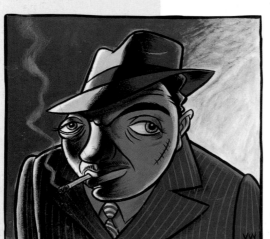

SEE ALSO
Need further treatment?
See Tutorial 24: Shading, page 90

Side lighting creates a stark, striking image composed of sharp contrasts between light and shadow. Different types of lighting can be very symbolic of a character's persona, and this juxtaposition between dark and light gives a character ambiguity. The lighting gives the reader mixed signals and allows the character to retain an interesting degree of mystery.

COLOR OF LIGHT

We've established that different colors have a range of atmospheric effects in a cartoon scene. This also applies to colored light, but note that some colors of light are synonymous with very specific things. Bright white, soft light indicates sunlight and yellow light often means streetlight at night.

Natural light is the standard light in which to present your characters because it best suits the two-dimensional aesthetic. Keep colors soft, use relatively light tones for shading, and keep shadows to a minimum.

Dim light can be achieved by using dark colors, such as purples, grays, and browns. The background is kept dark and strong colors are used for shading, but note that the character is given focus by the use of highlighting on his face.

Adding colored lighting to your scene can make it feel warmer or colder. Here, the dark background and the yellow light (possibly from a nearby streetlight) makes it clear this is a furtive nighttime scene. Note that colored light can also help to develop character. For example, a red light on an evil character will enhance his wicked appearance.

USING LIGHT CREATIVELY

Creative lighting is a great way to accentuate the physical trademarks of your characters. For instance, a bald head is perfectly highlighted and accentuated by light from directly above. Similarly, when presenting an endomorphic character, use an imaginary, directional light source to add highlights and shadows that will emphasize the character's fuller figure. Using light to emphasize your characters' features can give them an iconic presence and make them instantly recognizable and memorable.

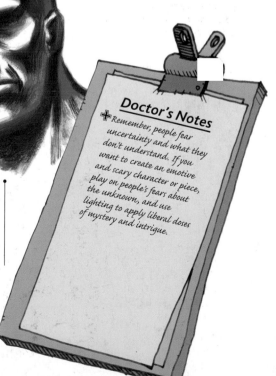

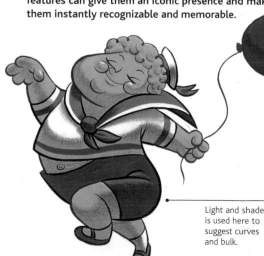

Light and shade is used here to suggest curves and bulk.

For atmospheric effect, use directional light to accentuate the ridges and planes in a face.

Doctor's Notes

✚ Remember, people fear uncertainty and what they don't understand. If you want to create an emotive and scary character or piece, play on people's fears about the unknown, and use lighting to apply liberal doses of mystery and intrigue.

Next subject please!

TUTORIAL 29

Viewpoint

Like lighting, viewpoint can alter our perception of a character by highlighting certain aspects of their physique. Different viewpoints can make a character look tall and overbearing or small and pathetic. It can even hint at unusual goings on in their mind, adding to the atmosphere of your scene.

FINDING A VIEWPOINT
To find an effective viewpoint you must first imagine yourself in the scene. Think about different attributes you could give your character that would make you feel the way you want your audience to feel. For instance, if you have a scary and overbearing character, who in real life would tower over you menacingly, choose a low viewpoint for your reader in order to emphasize your character's grand stature and powerful presence.

FRAMING YOUR SHOT
In the same way that you frame a photographic shot, moving backward and forward deciding what to keep in or exclude from the image, you need to frame your picture. You can opt for an extreme close-up, an extreme long shot, or something in between. Your choice of frame will affect how your audience reacts to your picture.

SEE ALSO
Need further treatment?
See Tutorial 14: Building Cartoon Heads and Faces, page 52

Viewed from above, characters appear small and insignificant. Because we look down on the subject, we immediately feel at ease due to our greater physical magnitude and we can concentrate on the character's less immediate qualities.

The standard cartoon view is straight on. More often than not, this is the best choice because its lack of perspective takes full advantage of the 2-D medium. It makes our figures appear neither small and feeble nor large and threatening. This is perfect for the majority of cartoons, which focus on comical themes that work better if the audience can find an affinity with the characters.

An extreme close-up tends to magnify the image beyond what the eye would normally be able to focus on comfortably. Using this shot, we can concentrate on tiny details that may not otherwise be prominent. For instance, a facial shot may comprise just one feature.

A normal close-up view offers an extremely intimate shot of a person (or object). We can see them in detail without getting so close that we don't know what we are looking at. The classic example is a shot of a face, framed so very little background is visible. This can give us an insight into what the character is thinking because we get a clear, uninterrupted view of their expression.

Viewed from below, a character looks large and imposing with lots of presence. Because we are looking up at the subject, we are given the impression that they are taller than we are, and often this triggers a feeling of fright or alarm as might happen in real life.

A bird's-eye view is an unnatural but striking angle that places the reader directly above the subject. It can be used as an establishing shot, and occasionally for action sequences, but because people and objects look very different from this angle, it can sometimes be confusing for the reader and should be used sparingly.

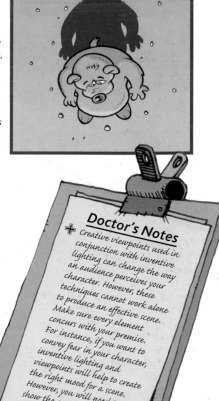

View a character from an oblique angle and immediately we get the impression that something is not right. The power of suggestion can be a useful tool in creating atmospheric stories, and human nature dictates that the hint of unusual goings-on can be more intriguing than their realization. Curiosity may have killed the cat, but it definitely made the cartoon interesting!

Doctor's Notes

Creative viewpoints used in conjunction with inventive lighting can change the way an audience perceives your character. However, these techniques cannot work alone to produce an effective scene. Make sure every element concurs with your premise. For instance, if you want to convey fear in your character, inventive lighting and viewpoints will help to create the right mood for a scene. However, you will need to show the emotion primarily through your character's expression and body language if you want to have an impact on your reader.

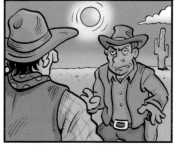

A medium shot will show a figure or figures (a "two shot" will contain two figures, a "three shot" will contain three, etc.) from the legs or waist up, and is traditionally suited to dialogue scenes. One interesting variation on this shot is the "over the shoulder" shot, in which we see a character over the shoulder of another character, as well as part of the second character's head and shoulders.

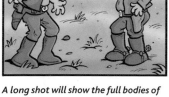

A long shot will show the full bodies of one or more of the characters, plus some of the surrounding scenery. This is ideal for action sequences.

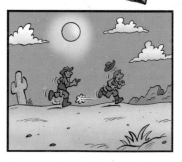

An extreme long shot is useful for scene setting, and normally shows an exterior, such as a building or landscape. It is a great way to start a story or chapter, because it immediately gives the reader information about the location of the forthcoming scenes.

Next subject please!

TUTORIAL 30

Arranging the Action

In cartoon art, a picture that groups its action into concentrated areas looks more coordinated, professional, and interesting than one without structure. Audiences always appreciate cartoons that have a well thought-out, detailed layout over one that has been put together in a haphazard way. The important elements of the picture should be arranged inside one or two primitive shapes to maximize impact, so the reader knows which area of the picture to concentrate on.

SEE ALSO
Need further treatment?
See Tutorial 27:
Setting,
page 100

The triangular man at the top of the page dominates this image.

These characters have been grouped into shapes and arranged on different planes.

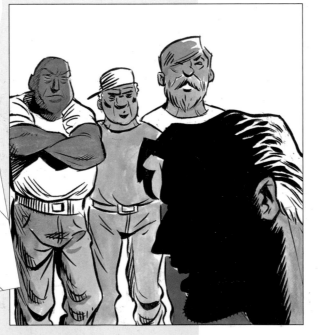

Focus can be drawn to different parts of a scene by breaking the characters or other elements down into shapes and arranging them on different planes (or spatial dimensions). This technique has been used very effectively in this illustration (left), where different lighting effects have been used on each of the two planes. The focus is drawn to the characters in the background that are well lit, while the man's head in the foreground is just a silhouette.

When composing your cartoon, you will have to give consideration to scale. If the emphasis is on a certain character, he or she can be brought to the foreground, almost filling the cartoon. Or perhaps the scenery is more important? In which case your characters can be placed in the background.

Here, the reader's eye is led to the action through compositional lines, in this case, the speed lines of the punch. However, all sorts of other elements (arms, furniture, perspective features of the landscape) may "point" to the center of interest.

By quickly mapping out the scene with simple shapes, you can clearly see how the action will appear.

See how a space has been inserted between the group of character shapes and the main character's shape.

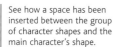

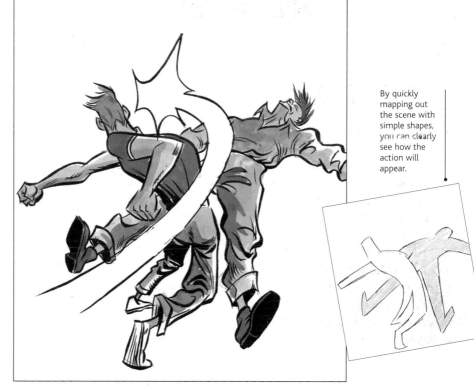

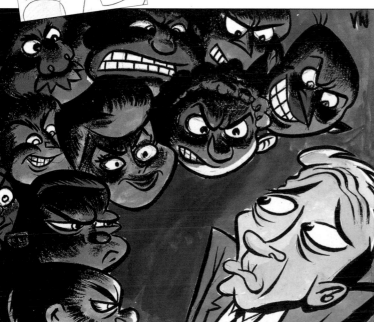

Sometimes the main character or object is given prominence by being surrounded by empty space. The cartoonist will sometimes erase lines around the character or arrange the composition so that the character is singled out, away from the rest of the crowd.

Doctor's Notes

More often than not, simplicity is the key when arranging the action in a scene. You don't want a confusing picture that is cluttered and messy, you want a clear and stylish arrangement of characters and props that won't detract from the story. If in doubt, simplify it.

Next subject please!

TUTORIAL 31

ER: Making Good Your Screw-ups

No matter how hard you try or how good you are, sooner or later you will make a mistake. Mistakes are endlessly frustrating, but before you start tearing your hair out and banging your head against a brick wall (which may cause you some real problems), there are a number of quick and easy remedies you can try.

SEE ALSO
Tutorial 1: Stethoscope, Scalpel...Pencils, page 12;
Tutorial 2: Paints, Inks, and Other Equipment, page 14

PROCESS WHITE
Small smudges and other little glitches are easy to conceal—just wait for your ink to dry completely, and then paint a thin layer of undiluted process white over the top. If you need to redraw an area, be patient, and make sure your paint has dried first—otherwise you will make more of a mess than you had in the first place!

ERASERS
Pencil errors can easily be corrected with an appropriate eraser. Plastic erasers are smooth and efficient for general correction. Kneaded erasers lift fine pencil lines, smudges, and loose dirt, and can be molded into shape.

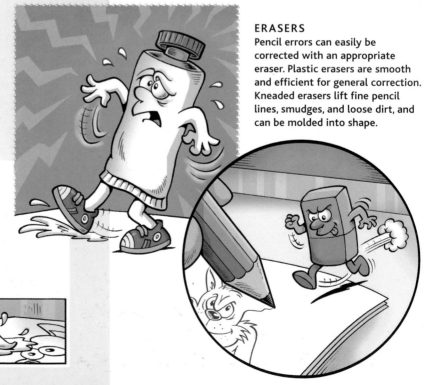

SCRATCHING

When you have been using smooth-surfaced line board or paper, it is possible to remove the offending error by scraping the surface layer of the paper away with a curved frisket blade. Don't press too hard, because you want to take off as little paper as you can. When you have finished, simply redraw your illustration over the top. Take your time with this because you can only get away with doing it once on each area.

PATCHING

This technique sounds almost too easy, but it really works. It involves cutting a new piece of paper large enough to cover the spoiled area, gluing it over the top, and redrawing the bungled bit. For a professional finish, paint over the edges of the new paper with process white. For a truly monumental error, you may choose to cut out the good part of the picture and graft it onto a new piece of paper altogether. For any cutting, use a cutting mat and scalpel—scissors will agitate the paper's edges so it won't lie flat.

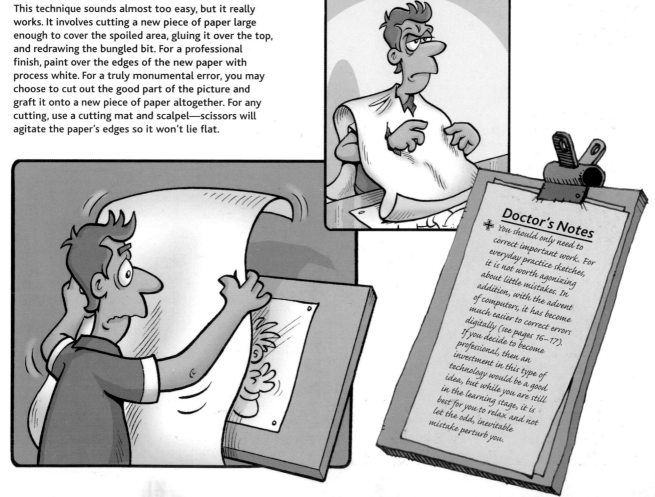

Doctor's Notes

You should only need to correct important work. For everyday practice sketches, it is not worth agonizing about little mistakes. In addition, with the advent of computers, it has become much easier to correct errors digitally (see pages 16–17). If you decide to become professional, then an investment in this type of technology would be a good idea, but while you are still in the learning stage, it is best for you to relax and not let the odd, inevitable mistake perturb you.

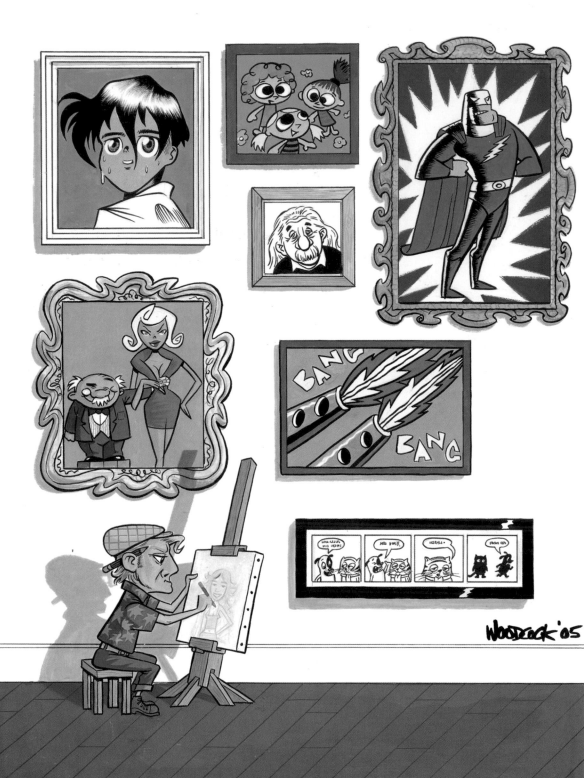

Adapting Your Style

In the previous chapters, we have established a **good**, **solid technique** for constructing **eye-catching** cartoon figures, but that is just the foundation for our cartooning work. ✚ Creating a **good cartoon** takes **originality** and **flair**, so it is important to branch out with your style as much as possible. ✚ With the skills and knowledge you have already acquired, you are ready to **leap into** a whole **world** of **graphic styles** and **genres**.

GALLERY 1: Satire

The purpose of satire is to mock human weakness and comment on politics and events of the day, so when creating satirical cartoons you walk a fine line between being funny and being offensive. It is important to know your audience. The best pieces of satire come from simple ideas that are well observed and presented, but if a satirical cartoon is poorly observed or the cartoonist has misjudged the audience, the satire will fail. Making it look easy can actually be very difficult.

FEATURES OF SATIRICAL CARTOONING:

- Culturally familiar
- Attacks a folly
- Illuminates a truth
- Thought-provoking

LEARN TO RELATE

To make a good satirist, you need three vital ingredients. First, you need to make sure you talk about a subject that is familiar to your audience. Second, you need to expose a vice or folly that most people will recognize. The third and most important ingredient is humor—you need to be funny! It is a good idea to work hard on your own individual style until you have refined it into something your audience will understand and hopefully find amusing.

TONY HUSBAND
Drawn in fiber tip marker on white board, this image pokes gentle fun at the urban affectation of carrying offspring Native American style, which is often more for the parent's convenience than for the child's.

"That reminds me—the strap broke on ours. I must get it repaired."

BOB STAAKE
This color cartoon finds humor out of the literal depiction of the elements of a news story, in this case depicting the launching of a European "baby" cheese in the U.S.

CAPT. H.R. HOWARD (1860)
The scratchy pen-and-ink style immediately places this illustration in the 19th century and mocks the aspirations of amateur astronomers to discover something missed by the professionals.

"Thank you, Brickley, but I think I'll walk to the office this morning."

JOHN DONEGAN
This is the kind of cartoon that turns up in generic magazines like Reader's Digest and sets its sights on an easy target—the rich. Drawn in ink and wash.

JOHN DONEGAN
This cartoon meets the criterion of cultural familiarity brilliantly and poses an incisive question— what exactly is a "Pooh"? Rendered in pen and ink, and ink wash.

"Winnie the What?"

D.L. MAYS
A lavish color rendering is used to lampoon fine art and suburban apologia at the same time. And the joke is something of an antique in itself.

"You'll have to excuse the mess—
we've got the painters in."

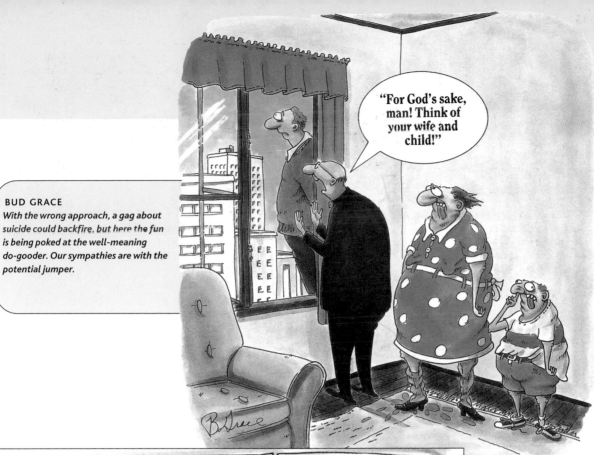

BUD GRACE
With the wrong approach, a gag about suicide could backfire, but here the fun is being poked at the well-meaning do-gooder. Our sympathies are with the potential jumper.

"For God's sake, man! Think of your wife and child!"

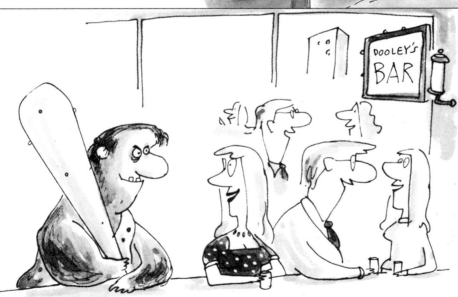

SCHWADRON
Again, the audience must be familiar with the old cliché about the "caveman" approach to capturing the attention of the female of the species. The gag is enhanced by the roughness of the sketch.

"One look at you and I said, 'Now here's a guy who's not going to fool around with silly opening one-liners'."

GALLERY 2: Manga

"Manga" is the Japanese term for any kind of comic book art, although homegrown Japanese Manga has a unique style and feel. It generally targets a more mature demographic and deals with sophisticated subjects and themes, which are usually quite serious compared to their Western counterparts.

Graphically, in comparison to Western comic art, Manga is extremely stylized. Usually, characters are drawn slightly out of proportion, with enlarged heads and huge eyes, but otherwise they bear a much closer resemblance to real humans than characters found in comic art of the West.

FEATURES OF MANGA CARTOONING:

- Characters with large eyes, small mouths, hair in primary colors
- Characters often proportioned like children
- Exaggerated emotions

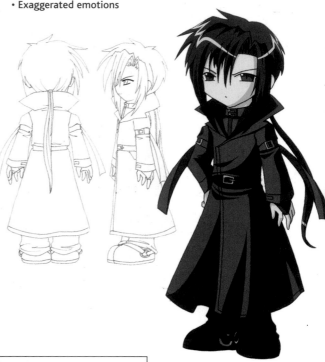

WING YUN MAN
Draconis
The traditional Manga look seeks to depict the characters as children or young people. This is achieved by drawing eyes and heads disproportionately large. Odd hairstyles are also a requirement.

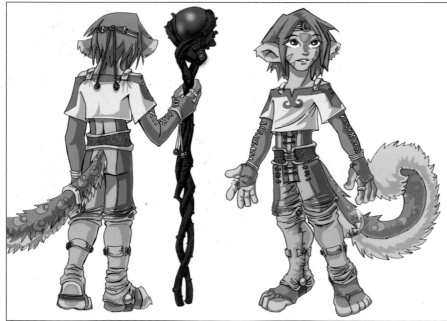

C. DESCARTES
Anthropomorphic animals are also popular in Manga. Here, only the strange ears and the tail give us a hint that we're looking at an animal rather than a human. This style of Manga is called "Bishoujo."

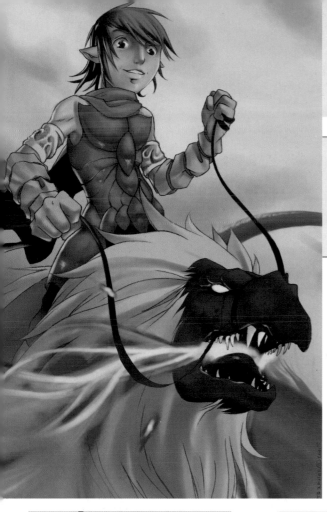

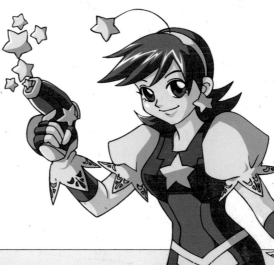

XAVIER COLLETTE
This image of a warrior aboard his fire-breathing dragon is a beautiful example of the overtly stylized effect often seen in Manga cartooning. The coloring, particularly the fiery breath, is superbly executed.

IRMA S. AHMED (AIMO)
Star Overload
This image by Aimo is in the whimsical "Shojo" style. Shojo is often designed for adolescent girls and concerns itself with romantic themes.

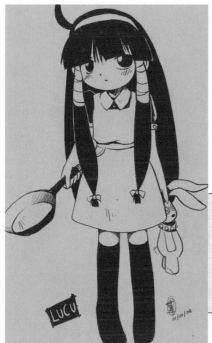

LIM LEE LIAN
Lucu
The "Kodomo" style of Manga is pitched toward the youngest readers.

2003

IRMA S. AHMED (AIMO)
Amber
*This character study of Revan by Aimo was intended for a
Dark Horse Comics Star Wars story—note the Jedi robes
and the light-saber on her belt.*

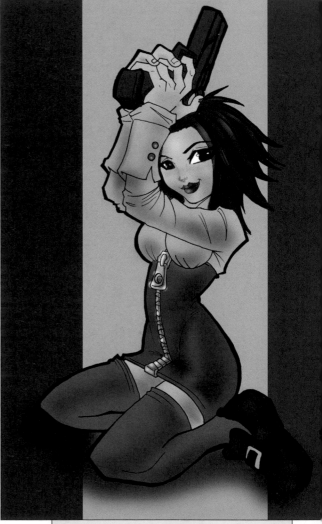

VIVIANNE
*A classic example of Shojo Manga. The soft pastel colors and
softer, more feminine hairstyle point toward the romantic.*

C. DESCARTES
*A Girl and her Gun is a character study for the Shonen
style of Manga. The content is aimed entirely at
adolescent boys.*

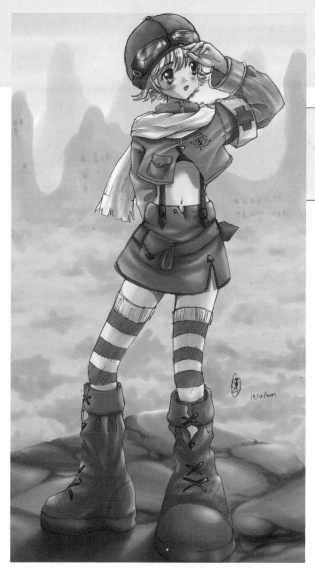

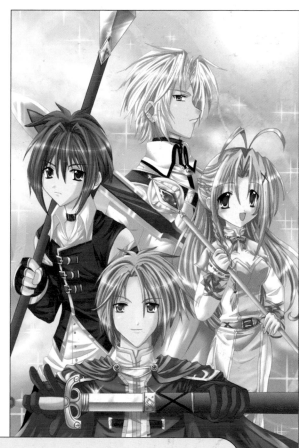

LIM LEE LIAN
This generic Manga drawing could fit comfortably into either the Shonen or Shojo styles—the character could be in search of hidden treasure or romance…

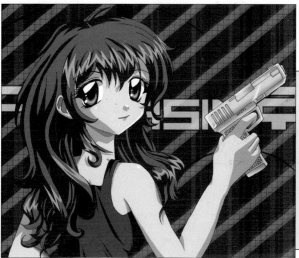

WING YUN MAN
(Above) This group of warriors, apparently about to embark on a mission against the forces of evil, displays many typical Manga features: large eyes, small mouths, brightly colored hair, and stylized clothing and weapons.

(Left) Gun Girl Assassin
Cute girls and big guns almost always add up to the Shonen style of Manga, which is designed for adolescent boys.

GALLERY 3: Comic Strip

The humble comic strip comes in all shapes, sizes, and forms, but many of today's comics are still influenced by the same vintage masterworks, such as those by DC Comics or Marvel Comics. Comic strips started to become popular in the late 1930s—this was due both to mass newspaper circulation, and also to exciting stories and colorful characters, the same qualities that attract comic readers today. The saying, "If it ain't broke, don't fix it," certainly rings true of these classic magnum opuses!

FEATURES OF COMIC STRIP CARTOONING:

- Use three or more pictures to tell a story
- Character driven
- Dialogue usually presented in speech balloons

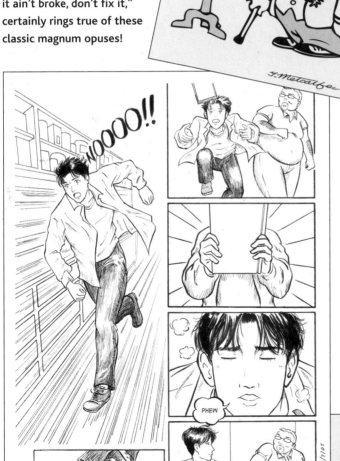

TREVOR METCALFE
Trevor Metcalfe's work is firmly in the tradition of the British weekly comic papers that flourished up until the 1980s. Few of these survive today, but Beano and Dandy are among the best known.

CATHERINE YEN
Simply rendered in pen and ink, this series of pictures builds up the story quickly and concisely. Few words are necessary to convey the mood. Note how the closely drawn perspective lines in the first picture also help to achieve a sense of urgent movement.

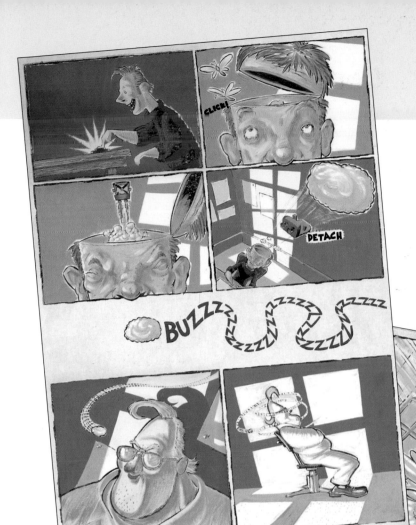

VINCENT WOODCOCK
This two-page continuity by Vincent Woodcock is very European in its surrealistic style, and manages to convey the narrative with minimal use of words.

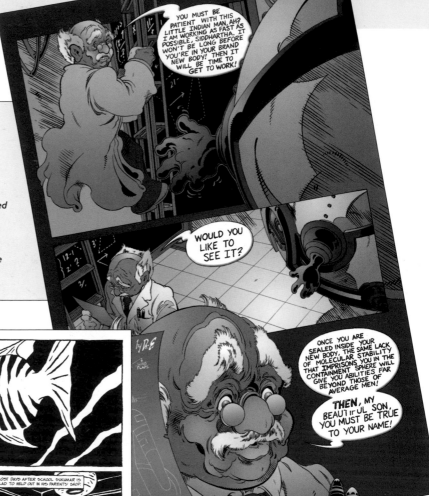

SHANTH ENJETI
Springball
Dialogue in comic strips is of necessity rather clipped. It is therefore vital for a comic-strip artist to create the correct expressions called for by the script, in order to aid the storytelling process. This example captures the subtleties of the human face very effectively.

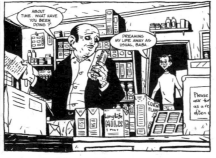

DAVID HINE
Strange Embrace
David Hine's Strange Embrace *is a weird and obsessional horror story and a major departure from the work he produced for 2000AD.*

GLEN HANSON & ALLAN NEUWIRTH
Chelsea Boys
The highly stylized Chelsea Boys *uses a newspaper format to tell its stories of three gay roommates in New York City. The strip is driven by the strong characters, each of whom has a different physical type and slightly different body language.*

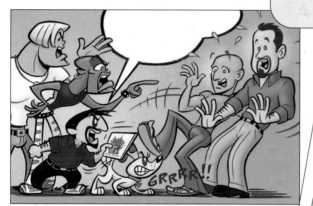

MICHEL GAGNÉ
Zed: Volume One
Zed is a cute alien in a strip by Canadian cartoonist, Michel Gagné. The series has a huge following and has been collected into a graphic album.

STEVE WHITAKER
The standard three-panel layout is an immensely popular format for newspaper comic strips. Usually following a formula of intro, setup, and punchline, the newspaper gag strip is one of the oldest forms of comic strip.

GALLERY 4: Prime Time Cartoons

As more and more people discover the versatility of cartoons, they are being used as the mainstay of prime time television entertainment. The cartoon style can help a show appeal to a wider audience, and its attention-grabbing qualities will mean that often more people take an interest in a new animated show than a new show of any other kind.

MONSTER APPEAL!

Prime time cartoons are all about ratings, and as such, they need to appeal to the broadest audience possible. Therefore, it is important for the style to remain relatively neutral—they can't be too obscure or stylized. The most successful cartoonists tend to settle for an understated aesthetic that is also vividly colorful and subtly comical. This allows the characters to retain their initial impact over a number of outings.

FEATURES OF PRIME TIME CARTOONING:

• Animated cartoon drawings

• Like comic strips, a sequence of pictures is used to tell a story; each scene in an animated show or movie represents approximately one panel in a comic strip

• Generally made by a team of artists, rather than just one person

WING YUN MAN
Telephone Icecream
The artist created Telephone Icecream *as an animé project together with animator Rik Nicol. This type of Manga is perfect for prime time with its bright colors and easily recognizable characters.*

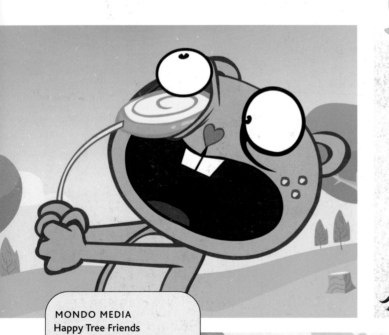

MONDO MEDIA
Happy Tree Friends
This is an anarchic spoof of children's funny animal cartoons and comes across as a junior version of "Itchy and Scratchy" from The Simpsons.

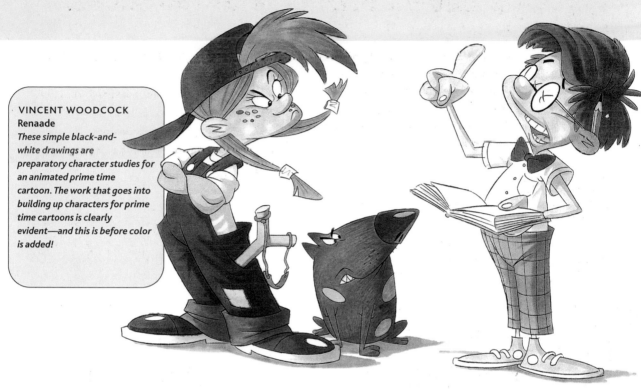

VINCENT WOODCOCK
Renaade
These simple black-and-white drawings are preparatory character studies for an animated prime time cartoon. The work that goes into building up characters for prime time cartoons is clearly evident—and this is before color is added!

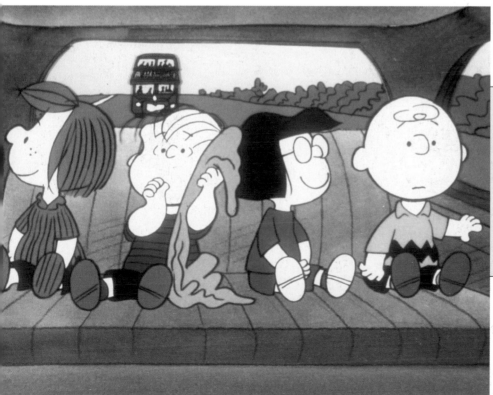

CHARLES M. SCHULTZ
The Charlie Brown & Snoopy Show
Based on the classic Peanuts comic strip, which dates back to the 1950s, the gentle humor of the animated Charlie Brown cartoons has massive popular appeal.

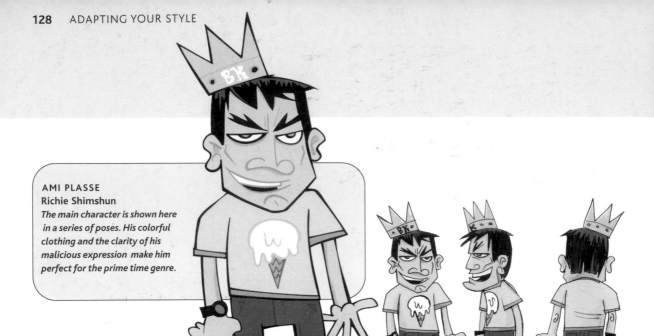

AMI PLASSE
Richie Shimshun
The main character is shown here in a series of poses. His colorful clothing and the clarity of his malicious expression make him perfect for the prime time genre.

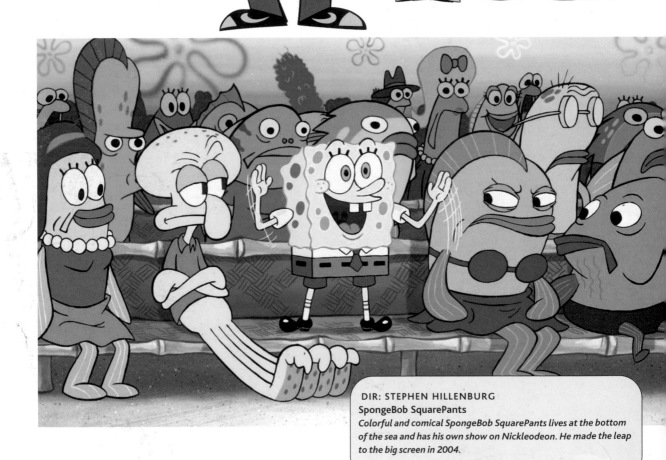

DIR: STEPHEN HILLENBURG
SpongeBob SquarePants
Colorful and comical SpongeBob SquarePants lives at the bottom of the sea and has his own show on Nickleodeon. He made the leap to the big screen in 2004.

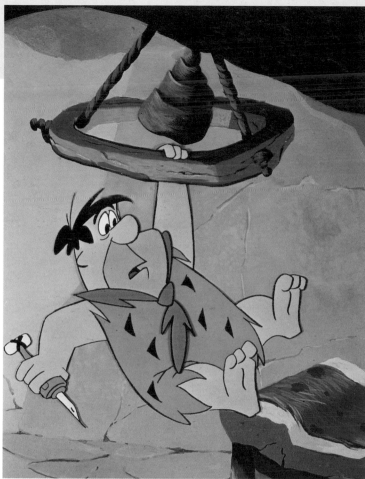

WARNER BROS
The Flintstones
Caveman-about-town Fred Flintstone and his family have been staples of prime time television viewing for decades. The show was the first animated series on network television and was designed to appeal to the whole family.

VINCENT WOODCOCK
Lance Clifton/
Captain Lazer
Disney animator Vincent Woodcock's Captain Lazer was drawn for a TV animation series, but was never broadcast. The character was influenced by old-style superhero comics.

GALLERY 5: Caricature

Visually, caricatures are a playful and fun way of satirizing faces. Features are contorted into strange and wacky proportions and arranged in humorous positions. Graphically, caricature is a compromise between the strong outlines and minimal shading of cartoons, and the more recognizable realism of life drawing—an interesting fusion that can produce surprising results!

FEATURES OF CARICATURE CARTOONING:

• Exaggerates a person's features to comic effect
• Seeks to reduce a person's face to a few lines
• Instantly recognizable

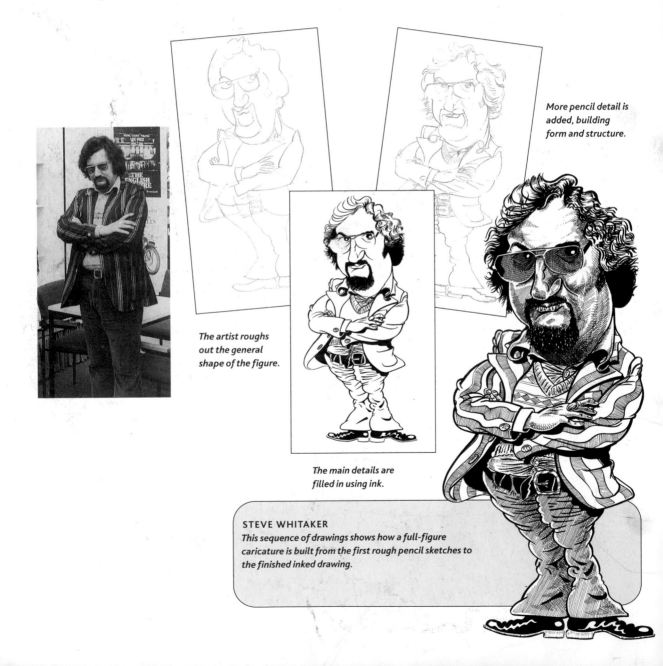

More pencil detail is added, building form and structure.

The artist roughs out the general shape of the figure.

The main details are filled in using ink.

STEVE WHITAKER
This sequence of drawings shows how a full-figure caricature is built from the first rough pencil sketches to the finished inked drawing.

ERICA MISSEY
Brad Pitt
Big hair, big eyes, and the exaggerated clean jawline perfectly capture the young Brad Pitt.

STEVE WHITAKER
Fred Astaire
The enlarged chin and nose demonstrate the classic caricature. In addition, the clean pen-and-ink lines of the portrait evoke Fred Astaire's smooth dancing style.

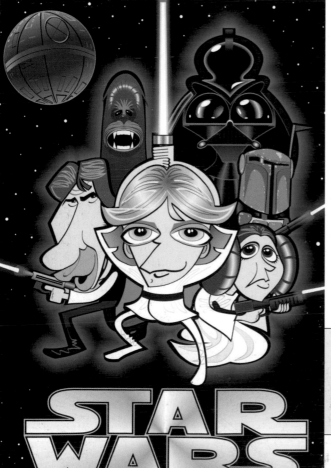

GEORGE WILLIAMS
Star Wars
George Williams' parody of the Star Wars movie poster is fun and has a touch of Manga about it.

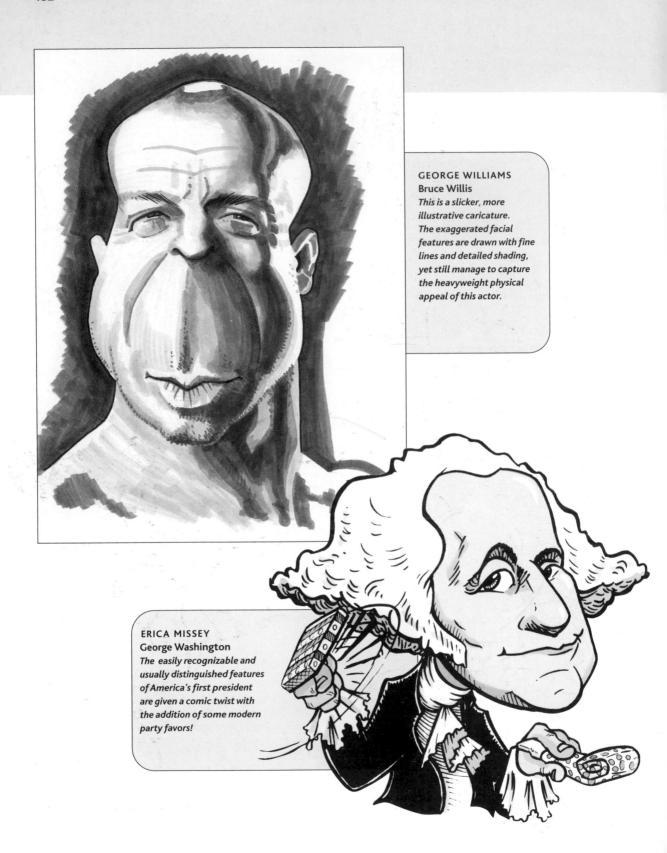

GEORGE WILLIAMS
Bruce Willis
This is a slicker, more illustrative caricature. The exaggerated facial features are drawn with fine lines and detailed shading, yet still manage to capture the heavyweight physical appeal of this actor.

ERICA MISSEY
George Washington
The easily recognizable and usually distinguished features of America's first president are given a comic twist with the addition of some modern party favors!

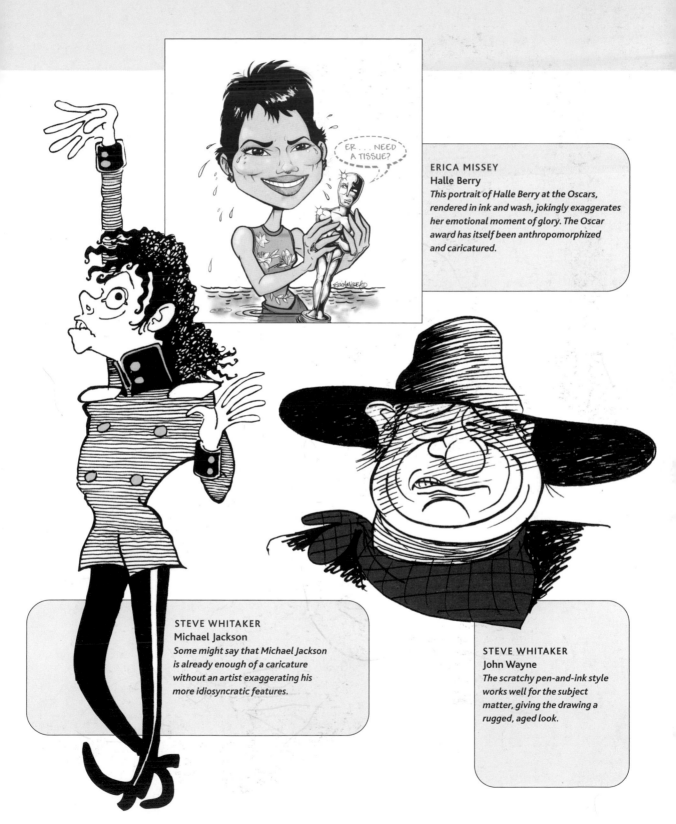

ERICA MISSEY
Halle Berry
This portrait of Halle Berry at the Oscars, rendered in ink and wash, jokingly exaggerates her emotional moment of glory. The Oscar award has itself been anthropomorphized and caricatured.

ER . . . NEED A TISSUE?

STEVE WHITAKER
Michael Jackson
Some might say that Michael Jackson is already enough of a caricature without an artist exaggerating his more idiosyncratic features.

STEVE WHITAKER
John Wayne
The scratchy pen-and-ink style works well for the subject matter, giving the drawing a rugged, aged look.

GALLERY 6: Pop Art

Pop art was a hugely influential visual arts movement in the 1950s and 1960s. Its inspiration was derived from mass culture, with many pop artists finding their ideas in unusual places, such as comic strips, road signs, and even soup cans! Pop art has had an effect on subsequent fashion and commercial design even to this day, when the same bright aesthetic can be seen in shopping malls and in advertising all over the world. The secret to its success has been capturing the attention of a mature, sophisticated audience using the bold, visual characteristics of cartoons, often with ironic overtones.

FEATURES OF POP ART:

• Borrows from popular culture with ironic effect
• Bold, vibrant colors

ROBERT DALE
This image is very much influenced by Roy Lichtenstein's 1950s comic strip style. Note the trademark motion lines and the rather cheesy starbursts on the car's windscreen.

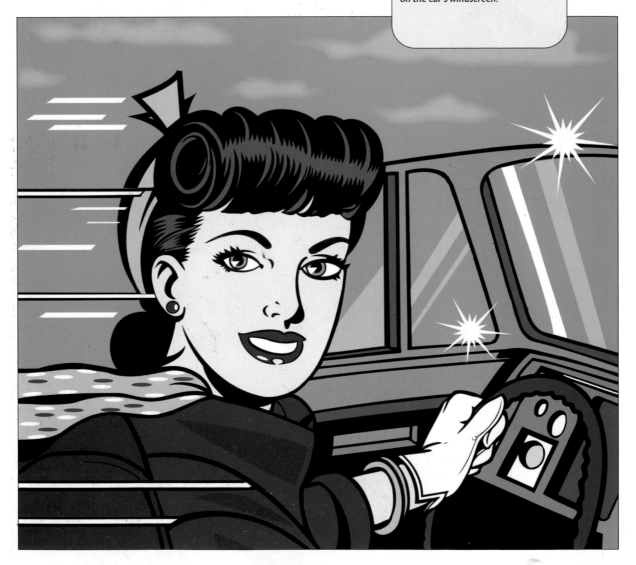

ROBERT DALE
American Boxing Glove
This artist has drawn influence from popular superhero comic strips. This is particularly seen in the use of typical cartoon devices (see pages 66–67), including a sound bubble used to indicate impact.

JOHN CLEMENTSON
This is pure Andy Warhol, one of the main proponents of pop art. Warhol's portrait of Marilyn Monroe is his most famous example of this style; this picture is inspired by it.

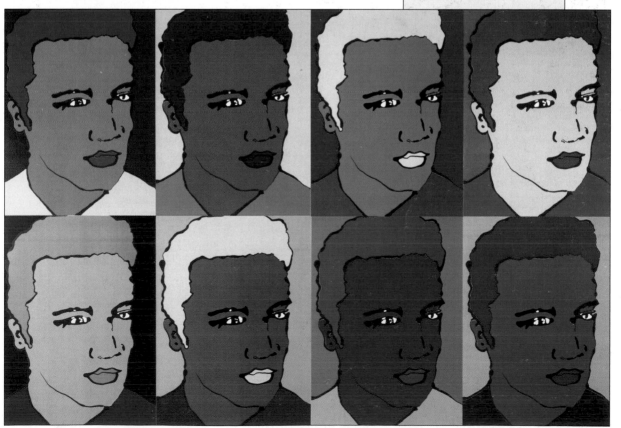

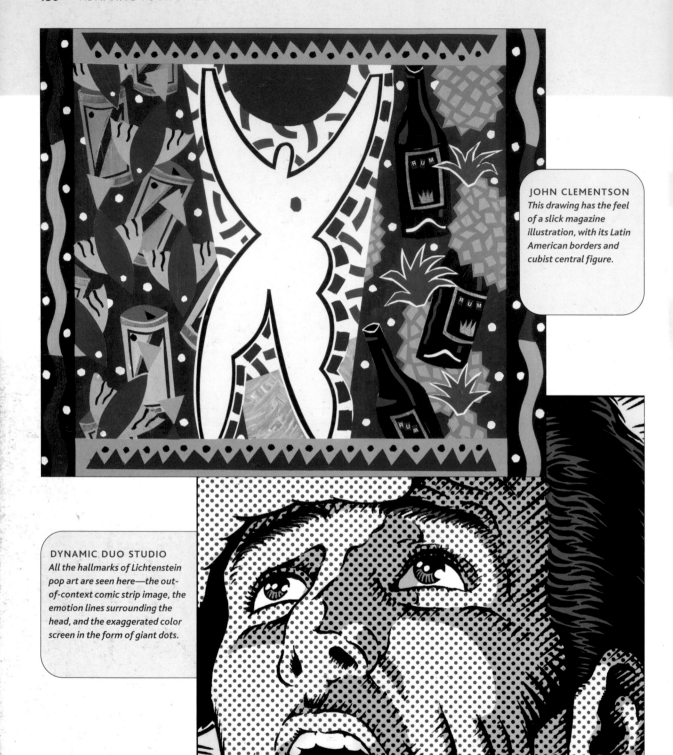

JOHN CLEMENTSON
This drawing has the feel of a slick magazine illustration, with its Latin American borders and cubist central figure.

DYNAMIC DUO STUDIO
All the hallmarks of Lichtenstein pop art are seen here—the out-of-context comic strip image, the emotion lines surrounding the head, and the exaggerated color screen in the form of giant dots.

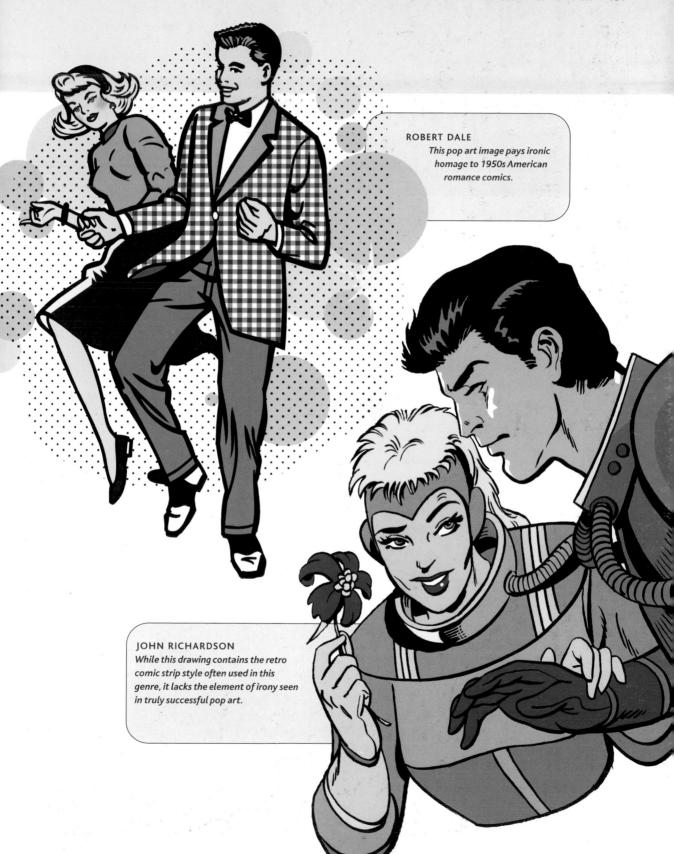

ROBERT DALE
This pop art image pays ironic homage to 1950s American romance comics.

JOHN RICHARDSON
While this drawing contains the retro comic strip style often used in this genre, it lacks the element of irony seen in truly successful pop art.

Resources

Cartoon Organizations

Anonima Fumetti (Italian cartoonists' society)
Centro Nazionale del Fumetto
C.P. 3242
Ufficio Postale Marsigli
Torino
Italy
Tel: +39 011 433 1465
Email: segreteria@anonimafumetti.org
Web: www.anonimafumetti.org

The Association of American Editorial Cartoonists (AAEC)
PO Box 37669
Raleigh
NC 27627
U.S.A.
Tel: +1 919 329 8129
Web: http://editorialcartoonists.com/index.cfm

Australian Cartoonists' Association
PO Box 318
Strawberry Fields
NSW 2016
Australia
Tel: +61 1300 658 581
Web: www.abwac.org.au

The Cartoon Art Trust
C/o Wintle Ltd
2 New Burlington Place
London W1S 2HP
United Kingdom
Tel: +44 (20) 7287 2867
Email: cartooncentre@freeuk.com
Web: www.cartooncentre.com

The Federation of Cartoonists' Organizations
Reuchlinstrasse 17 A
70178 Stuttgart
Germany
Tel: +49 711 5283371
Email: mpohle.cartoons@t-online.de
Web: www.fecoweb.org

Graphic Artists Guild
90 John Street
Suite 403
New York
NY 10038-3202
Tel: +1 212 719 3400
Email: admin@gag.org
Web: www.gag.org

The Japan Cartoonists' Association
I – 4 – 6 Ginza
Chuo–Ku
Tokyo 104
Japan
Web: www.nihonmangakakyokai.or.jp

La Maison des Auteurs de Bande Dessinée (French cartoonists' society)
Web: www.mdabd.com

Further Reading

Anatomy for Fantasy Artists, Glen Fabry, Ben Cormack (Barron's Educational Series, 2005)

The Animator's Survival Kit, Richard Williams (Faber & Faber, 2002)

The Art of Making Comic Books, Michael Morgan Pellowski, Howard Bender (First Avenue Editions, 1995)

Cartooning for the Beginner, Christopher Hart (Watson-Guptill Publications, 2000)

Cartooning with The Simpsons, Matt Groening, Bill Morrison (Harper Paperbacks, 1993)

The Complete Cartooning Course: Principles, Practices, Techniques, Brad Brooks, Tim Pilcher, Steve Edgell (Barron's Educational Series, 2001)

Drawing and Cartooning 1,001 Figures in Action, Dick Gautier (Perigee, 1994)

Drawing and Cartooning for Laughs, Jack Hamm (Perigee, 1990)

Duane Barnhart's Cartooning Basics: Creating the Characters, Duane and Angie Barnhart (Cartoon Connections Press, 1997)

Funny Pictures: Cartooning With Charles M. Schulz, Charles M. Schulz (HarperCollins, 1996)

How to be a Successful Cartoonist, Randy Glasbergen (North Light Books, 1995)

How to Create Action, Fantasy and Adventure Comics, Tom Alvarez (North Light Books, 1996)

How to Draw Cartoon Characters, Renzo Barto (Watermill Press, 1994)

How to Draw Comics, Gwenn Mercadoocasio (Longmeadow, 1994)

How to Draw Comics the Marvel Way, Stan Lee, John Buscema (Fireside (reprint), 1984)

L'art de la Bande Dessinée, Duc (Ed. Glénat, 1996)

Let's Toon Caricatures, Keelan Parham (Lunar Donut Pr, 2003)

Timing for Animation, Harold Whitaker, John Halas (Focal Press, 2002)

The Total Cartoonist, Ken Muse (Prentice-Hall, 1985)

Understanding Comics: The Invisible Art, Scott McCloud (Kitchen Sink Press, 1993)

Glossary

Aesthetic A particular theory or conception of art.

Anatomy The structural makeup of a body, (human or animal).

Anthropomorphism The attribution of human characteristics to nonhuman things.

Bitmap A text character or graphic image comprised of dots or pixels (picture elements) in a grid. Together, these pixels—which can be black, white, or colored—make up the image.

Body language The gestures, movements, poses, and expressions that a person uses to communicate.

Caricature Ludicrous exaggeration of the characteristic features of a subject.

Cartoon 1. A drawing intended as satire, caricature, or humor; 2. A simplistic, unrealistic portrayal.

Cliché Something that has become overly familiar or commonplace.

Cold-pressed paper Paper pressed between cold cylinders (sometimes called NOT, meaning "not hot-pressed"). This process results in a rougher texture than hot-pressed paper.

Color wheel A circular diagram of the color spectrum used to show the relationships between the colors.

Comedy (Relating to cartoons) A humorous or farcical event or series of events.

Devices A set of conventions used by cartoonists that act to represent actions, noises, and states of mind. They make things visible that are not physically present.

Dip pen A pen, typically with a replaceable split sheet metal point, that must be repeatedly dipped into an external inkwell while writing or drawing.

Dots per inch (dpi) The unit of measurement that represents the resolution of a device such as a printer, imagesetter, or monitor. The higher the dpi, the better the quality.

Ectomorph Refers to a body type that is slender, angular, and fragile.

Endomorph Refers to a body type that is round, soft, and heavy.

Felt tip pen The drawing points of felt tip pens tend to be larger and softer than those of fiber tip pens. They are available in a wide range of shapes and sizes.

Fiber tip pen These have fine points made of a synthetic material and are available in a range of point sizes and colors. The ink may be water soluble in which case it can be blended with a brush. The more permanent inks tend to be alcohol based.

Flat color An area of color in which there are no modulations of tone.

Foreshortening A perspective technique used to create the illusion of an object receding into the background (or advancing into the foreground).

Fountain pen A pen that is supplied with ink from a reservoir in its barrel.

Freehand A drawing done without the help of any special equipment for accurately creating straight lines, circles, symbols, etc.

Highlight The brightest part of the subject.

Horizon line The horizon line in perspective drawing is a horizontal line across the picture. It is always at eye level—its placement determines where we seem to be looking from, a high place or close to the ground.

Hot-pressed paper Paper finished by pressing it between hot cylinders, resulting in a smooth surface.

Humor Something that is designed to be comical or amusing.

Inking Tracing over the rough pencil lines of a cartoon with ink ready for publication.

Line work Art work without shading or color added.

Manga Generally refers to a variety of styles and influences from Japanese comics.

Mapping pen A dip pen with a very fine nib, originally designed for map making.

Mesomorph Refers to a body type that is muscular and well-built.

Outline A line that marks the outer limits of an object or figure.

Palette 1. A dish or tray on which an artist lays out paint for mixing or thinning. May be made from wood, metal, plastic, or ceramic. 2. Also used to describe the range of colors a painter uses in a particular work.

Perspective Any graphic system that creates the impression of depth and three dimensions on a flat surface.

Pixels Any of the small, discrete elements that together constitute an image on a computer or digital video screen.

Pop art A style of art which takes its inspiration from commercial art and items of mass culture, including consumer products and cartoon characters.

Process white An opaque white gouache used for correcting and masking artwork that is intended for reproduction.

Proportion The harmonious relation of parts to each other or to the whole.

Props The visual elements of a scene, apart from the setting and the characters. Usually objects and items used by characters.

Satire A work in which human vice or folly is attacked through irony, derision, or wit. Satire is used to reveal flaws in human behavior or institutions with an intent to reform.

Shading Graded markings that indicate areas of light or shade in a painting or drawing.

Sketch A rough drawing, often made as a preliminary study.

Somatotype Body type.

Speech bubble A (usually) circular shape used in cartoon drawing to indicate speech. Dialogue is written within the shape and a pointer designates the speaker.

Speed lines A device used to indicate movement.

Stereotype A standard mental picture that is held in common by members of a group and that represents an oversimplified opinion or prejudiced attitude.

Stick figure A drawing showing the head of a human being or animal as a circle and all other parts as straight lines.

Technical pen These pens generally utilize an ink-flow-regulating wire within a tubular nib, enabling them to produce precise, consistent ink lines without the application of pressure.

Three-dimensional (3-D) Giving the illusion of depth or varying distances.

Two-dimensional (2-D) A flat image, lacking in depth.

Vector graphics A computer image made up of curves as created by drawing programs that use the PostScript language.

Viewpoint The direction from which you look at something.

Index

Acknowledgments

For Joan, with love.

Key: t = top, b = bottom, l = left, r = right
71tl Martin Shovel, *www.shovel.co.uk*; **114t** Tony Husband / Punch, Ltd;
114b Bob Staake, *www.bobstaake.com*; **115t** Capt. H. R. Howard / Punch, Ltd; **115b** John
Donegan / Punch, Ltd; **116t** John Donegan / Punch, Ltd; **116b** D. L. Mays / Punch, Ltd;
117t Bud Grace / Punch, Ltd; **117b** Schwadron / Punch, Ltd; **118t** Wing Yun Man,
www.ciel-art.com; **118b** C. Descartes, *www.electricvision.co.uk*; **119t** Xavier Collette,
http://users.skynet.be/fa081413/portfolio; **119r** Irma S. Ahmed (Aimo),
www.aimostudio.com; **119b** Lim Lee Lian, *www.lian.exorsus.net*; **120t** Irma S. Ahmed (Aimo),
www.aimostudio.com; **120r** C. Descartes, *www.electricvision.co.uk*; **120b** Vivianne,
www.viviane.ch; **121t** Lim Lee Lian, *www.lian.exorsus.net*; **121r** Wing Yun Man,
www.ciel-art.com; **121b** Wing Yun Man, *www.ciel-art.com*; **122t** Trevor Metcalfe,
www.trevortoons.com; **122b** Catherine Yen, *www.studiocyen.net*; **123** Vincent Woodcock;
124t Springball® is ™ and © Shanth S. Enjeti, *www.enjeticomics.com*; **124b** David Hine,
www.twoillustrators.com; **125t** Glen Hanson and Allan Neuwirth, *www.chelseaboys.com*;
125r Michel Gagné, *www.gagneint.com*; **125b** Steve Whitaker; **126l** Mondo Media,
www.happytreefriends.com; **126r** Wing Yun Man, *www.ciel-art.com*; **127t** Vincent
Woodcock; **127b** Photo12.com – Collection Cinéma; **128t** Ami Plasse, *www.amiplasse.com*;
128b Director: Stephen Hillenburg / Photos12.com – Collection Cinéma; **129t** Warner Bros /
The Kobal Collection; **129b** Vincent Woodcock; **130** Steve Whitaker; **131t** Erica Missey,
www.ericatures.com; **131r** Steve Whitaker; **131b** George Williams, *www.caricatures-uk.com*;
132t George Williams, *www.caricatures-uk.com*; **132b** Erica Missey, *www.ericatures.com*;
133t Erica Missey, *www.ericatures.com*; **133l** Steve Whitaker; **133r** Steve Whitaker;
134 Robert Dale / Images.com / CORBIS; **135t** Robert Dale / Images.com / CORBIS;
135b John Clementson / Illustration Works / GETTY; **136t** John Clementson / Illustration
Works / GETTY; **136b** Dynamic Duo Studio / Images.com / CORBIS; **137t** Robert Dale /
Images.com / CORBIS; **137b** John Richardson / Illustration Works / GETTY.

All other photographs and illustrations are the copyright of Quarto Publishing plc.
While every effort has been made to credit contributors, we apologize should there have
been any omissions or errors.